Keys to Painting
Color & Value

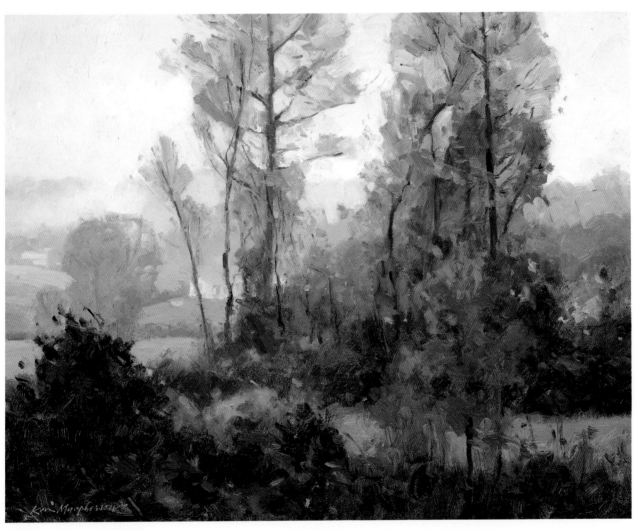

KEVIN D. MACPHERSON
Flaming Maple
Oil
16" × 20" (41cm × 51 cm)

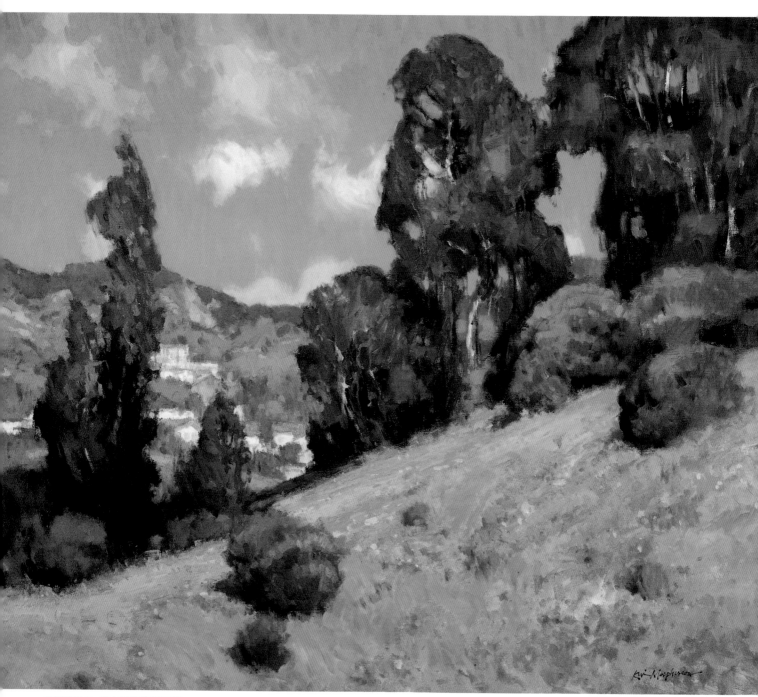

KEVIN D. MACPHERSON
Laguna Hillside
Oil
30" × 36" (76cm × 91cm)

Keys to Painting
Color & Value

EDITED BY RACHEL RUBIN WOLF

NORTH LIGHT BOOKS
CINCINNATI, OHIO
www.artistsnetwork.com

The following artwork originally appeared in previously published North Light Books (the initial page numbers given refer to pages in the original artwork; page numbers in parentheses refer to pages in this book).

Browning, Tom. *Timeless Techniques For Better Oil Paintings* ©1994. Pages 2-11, 16-19, 22-23, 31-33, 34, 35, 42-43, 80-81 (6, 10-23, 58-59, 66-69, 72-73)

Kaiser, Richard K. *Painting Outdoor Scenes in Watercolor* © 1993. Pages 50-55 (100-105)

Lawrence, Skip. *Painting Light and Shadow in Watercolor* © 1994. Pages 36-39, 66, 68-73, 84-87 (5,8, 38-45, 76-81)

Leland, Nita. *Exploring Color (revised edition)* © 1998. Pages 116-121 (94-99)

Macpherson, Kevin D. *Fill Your Oil Paintings With Light and Shadow* © 1997. Pages 17-23, 32-35, 38-39, 61 (1, 2, 60-65, 70-71, 74-75, 92-93)

Maltzman, Stanley. *Drawing Nature* ©1995. Pages 36-39 (24-27)

Simandle, Marilyn with Lewis Barret Lehrman. *Capturing Light In Watercolor* © 1997. Pages 84-91, 114-121 (84-91, 118-125)

Smuskiewicz, Ted. *Oil Painting Step by Step* © 1992. Pages 20-29 (28-37)

Szabo, Zoltan. *Zoltan Szabo's 70 Favorite Watercolor Techniques* © 1995. Pages 46-51 (106-113)

Szabo, Zoltan. *Zoltan Szabo's Watercolor Techniques* © 1994 . Pages 44-47 (114-117)

Treman, Judy D. *Building Brilliant Watercolor* © 1998. Pages 80-97 (46-55)

Zemsky, Jessica. *Capturing the Magic of Children in Your Paintings* © 1996. Pages 82-83 ([including cover art] 56, 82-83)

05 04 03 02 01 5 4 3 2 1

Library of Congress Cataloging in Publication Data

Keys to painting : color and value / [edited by Rachel Rubin Wolf].
 p. cm.
 Includes index.
 ISBN 1-58180-190-4 (pbk. : alk. paper)
 1. Painting—Technique. 2. Color in art. 3. Light in art. I. Rubin Wolf, Rachel
ND1488 .K49 2001
752--dc21 2001032617

Editors: Rachel Rubin Wolf and Bethe Ferguson
Interior production artist: Cheryl VanDeMotter
Production coordinator: Sara Dumford
All works of art reproduced in this book have been previously copyrighted by the individual artists and cannot be copied or reproduced in any form without their permission.

Metric Conversion Chart

To Convert Multiply by	To	
Inches	Centimeters	2.54
Centimeters	Inches	0.4
Ounces	Grams	28.4
Grams	Ounces	0.04

ACKNOWLEDGMENTS

The people who deserve special thanks, and without whom this book would not
have been possible, are the artists whose work appears in this book. They are:

Tom Browning
Robert Frank
Richard K. Kaiser
Barbara Kellogg
Skip Lawrence
Lewis Barrett Lehrman
Nita Leland
Kevin D. Macpherson
Stanley Maltzman

Susan McKinnon
Elin Pendleton
Douglas Purdon
Marilyn Simandle
Ted Smuskiewicz
Zoltan Szabo
Judy D. Treman
Jessica Zemsky

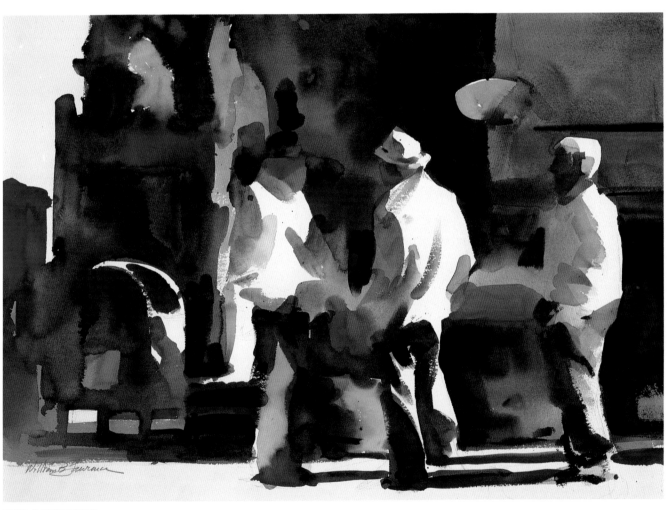

SKIP LAWRENCE
Fells Point Gathering
Watercolor
20" × 26" (51cm × 66cm)

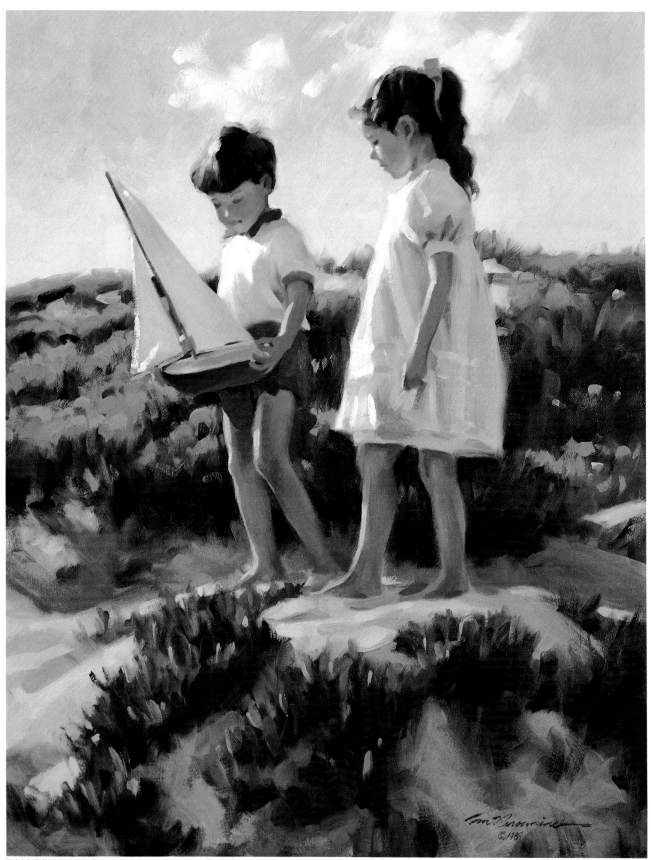

TOM BROWNING
Maiden Voyage
Oil
18" × 14" (46cm × 36cm)

TABLE OF CONTENTS

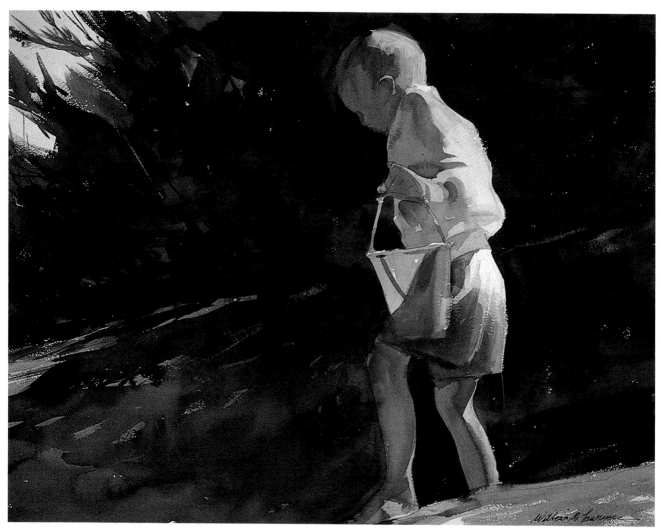

SKIP LAWRENCE
Joshua Exploring Little Beach
Watercolor
20" × 26" (51cm × 66cm)

INTRODUCTION

Tonal value and color are probably the two most basic and important elements in painting. Together, they define every form, mood and emotion in your painting.

This book brings together some of North Light's best artists in a variety of painting mediums to help you discover new ways to make use of these essential aspects of painting. The first two chapters of the book are dedicated to teaching you the basics of each of these elements, as well as some professional secrets. In the third and final chapter, these experienced artists and teachers show you how to use what you have learned to create special effects, including interpreting a variety of weather conditions, seasons and times of day.

You'll learn watercolor techniques from Zoltan Szabo for painting dramatic clouds and distant mist. Stanley Maltzman shows you how to effectively use tonal value to sketch foregrounds, middle grounds and backgrounds in pencil. Judy Treman shows you how to intensify your watercolors by creating a structure with tonal values. This is just a sampling of the many techniques and demonstrations you will find inside. The artistic secrets of these successful artists will help you bring your own painting to life.

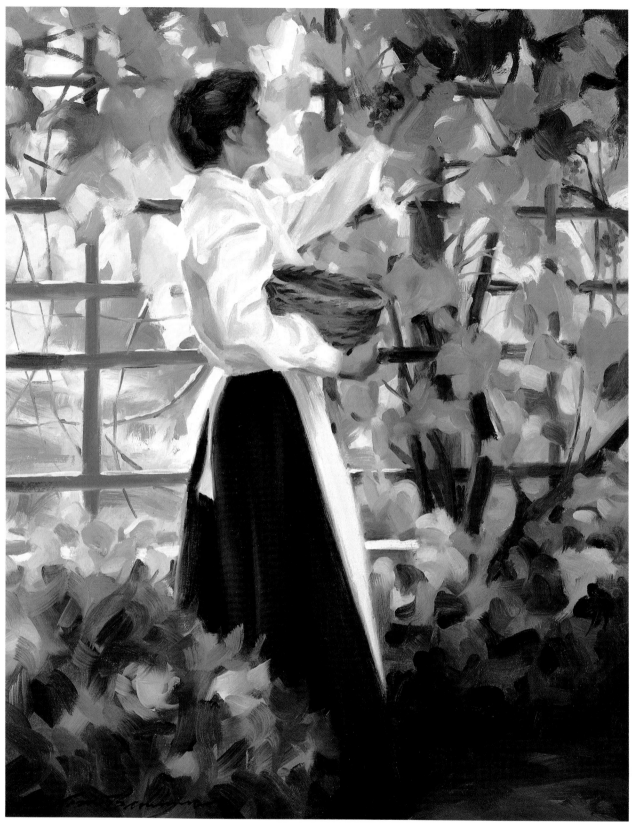

TOM BROWNING
The Grape Arbor
Oil
16" × 12" (41cm × 30cm)

Tonal Values, the Foundation

This book begins with the element of painting that many artists consider the most important: understanding values. Their use can make or break a painting. They are a major part of the foundation on which an artist builds a picture. Value control is consistently the number one problem that students and even professional painters have in producing successful paintings.

Even though I feel the concept of understanding light and values is basically simple, an entire book could easily be devoted to the subject. We've tried to simplify the process so you can apply it each time you paint a picture. When you begin to see how light falls on forms and creates values, painting becomes much easier. It simply makes a lot more sense.

This section should help those who feel lost when it comes to values, as well as those who are only looking for a few helpful hints. You will see how light creates values and how the artist can translate those values with paint, creating the illusion of form and depth on a flat surface. There are exercises for those who want to try it for themselves, and information and helpful guides for those who want to add to their existing knowledge and understanding of values.

The artwork on pages 10-23 was created by Tom Browning.

What Are Values?

Variations in the intensity of light make up light and shade. The word tone is often used to refer to a particular variation of light or shade.

These tones that vary in degree of lightness and darkness are called values and can be put on a scale of, for example, one to nine—one being the lightest and nine being the darkest. There are hundreds of degrees of gray from white to black, but for artistic purposes it's best to limit the number of values so the change from one to the next is easy to see. These changes, when used in a painting, become value relationships.

I'm sure you've seen value scales many times, but as I stated in the introduction, I believe values to be the single most important element of a painting. Understanding them is essential. Values must be dark in the right places and light in the right places. And it isn't enough to look at a value scale and say, "That's easy to understand—dark to light and eight variations in between—

simple." The true test comes with observing an object or a scene, translating its parts into values, and matching those values with paint to create the illusion of a three-dimensional object on a flat surface. This is the essence of painting. Understanding and controlling values should be your first objective as a painter.

To understand values is to understand light, not in an all-encompassing sense, but how light visually affects all that it touches. How it not only reveals the form, but flows over it, disappearing then reappearing. How it seems to gently caress subtle undulations or slam into an abrupt barrier, lighting it up before moving on. Its presence illuminates and creates areas of light, while its absence creates defining shadows. So as light travels along, coming into contact with one surface after another, it creates and leaves behind the lights and darks we call values.

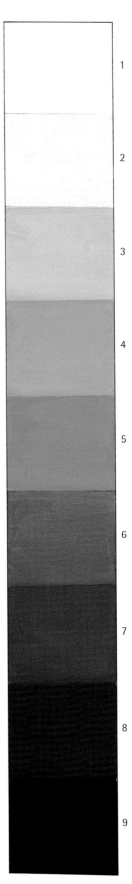

A Typical Value Scale
Although values also exist in colors and with a wider range than shown here, it is easier to see value relationships with a limited number of gray values.

Learning to Observe Light and Values

To understand values we first have to understand how light itself dictates values. Observation is the key to understanding the principles of light falling on a form. Whenever you look at an object, remember, the only reason you can see it and identify it is because light from some source is falling on it. This light not only reveals its overall shape, but also the irregular angles and planes of its surface. Every object or group of objects is unique in the way light falls upon it and changes as the light source changes.

When I started my art career, I worked primarily in pen and ink and scratchboard. Working in black and white forced me to relate everything in terms of values. I usually made sure that my reference was in black and white as well. This made my job of matching values relatively easy. But when I began working in watercolors and oils, I did a lot more painting from life. And I realized the objects in my paintings lacked solidity and convincing form. The reason was that I lacked the knowledge to observe my subject with an understanding of how light reveals form. Not just the overall shape, but all of its irregular surfaces that give it a unique character. When I finally learned to look at the world with this in mind, it was as if someone had turned on the light, and my work began to improve at a much faster rate.

The first thing to remember when observing light on form is that the surface of an object most perpendicular to the source appears the lightest (provided the object's surface is not multicolored or of varying values).

As the form of an object turns away from the source of light, darker values appear as shadows. As long as a single-light source is used, this observation usually holds true. It is not a hard-and-fast rule by any means. There are many circumstances that might alter this general rule, but it's still an important one to consider first when observing your subject.

To further understand this idea, take an object in the shape of a cube (such as a white box) and set it on a table under a single-light source. Tilt the cube so that one of the surfaces is directly perpendicular to the light. You can see that

this is now the lightest-appearing surface on the cube. In other words, this surface is now the lightest in value. Now start turning that surface away from the light. Notice it remains the lightest value until another side of the surface becomes equally exposed or more perpendicular to the light.

If you now understand how light first falls on an object revealing its form and creating light and dark areas, this next exercise will help you translate the values you see into values you create with paint. And not only will you be seeing value relationships, but you'll also be modeling form.

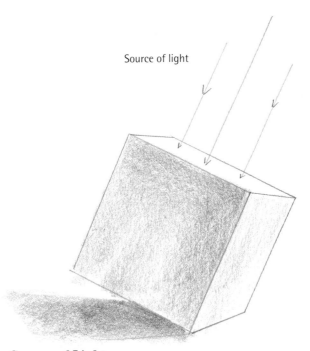

Source of light

Source of Light
The surface most perpendicular to the source of light appears to be the lightest surface of the form and, therefore, the lightest value. The surface opposite the light appears to be the darkest unless it is receiving light from some other source.

Translating Values to Paint

Place a white box on a table and position a light (100 watts) about three feet away and at about the same level (as shown below). Turn off any other bright lights in the room. You should be able to see three sides of the box. From now on I will refer to these sides or differing angles as planes. Note how the three planes are different in value. One is the lightest value, another is the darkest, and the third plane is a value somewhere between the other two.

With just black-and-white paints try matching values with those of the box before you. First, quickly sketch the box onto your canvas. Now locate the darkest plane and establish its value. Mine is somewhere around seven on the value scale. If you thought about making this plane as dark as say nine or ten, hold up a brush loaded with black paint in front of the box. You are now comparing a value made of paint with an existing value on the box. You'll see that the

darkest value on the box is far lighter than the black on your brush. In fact, the darkest dark should be a small accenting shadow at the base of the box. Next, locate the lightest plane and establish its value. Keep in mind that by establishing the lightest plane, you now have two planes to compare. This makes finding the value of the third plane easy. Establish the middle value and paint the third plane.

Step back and compare the values on your canvas to the actual subject. If the relationship between each of them does not correspond, simply adjust your paint mixture until it matches what you see before you. These value relationships are key to establishing a convincing form.

Comparison is essential in matching the proper values on your palette with the values on your subject. Remember, this exercise is intended to develop skills of observation. When doing an actual painting, you may want to make a value darker or lighter than it actually appears if it works better in your particular composition.

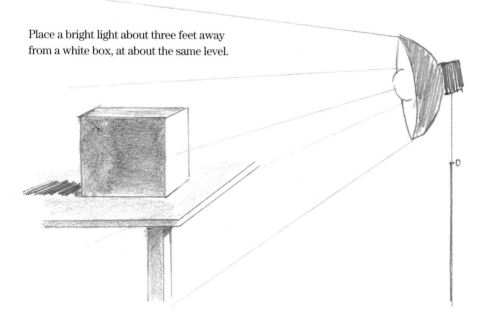

Place a bright light about three feet away from a white box, at about the same level.

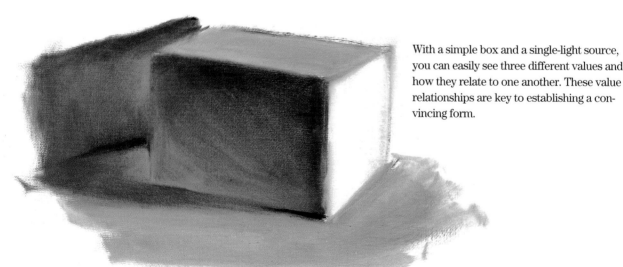

With a simple box and a single-light source, you can easily see three different values and how they relate to one another. These value relationships are key to establishing a convincing form.

Here's something to remember when making these comparisons. Whenever you look from your painting back to your subject, try doing so quickly. If you stare at your subject too long, value differences become less evident. Your eye operates much like the lens of a camera: The length of time it's open determines how much light is let in. Shadows become lighter the longer you stare, making it more difficult to capture the relationship of light and dark values. It's important to get used to glancing at your subject in this most important stage of establishing values.

If you followed and completed this exercise, you have just modeled a form. As simple as it may seem, observing value relationships and translating values into a modeled form are essential to creating representational art.

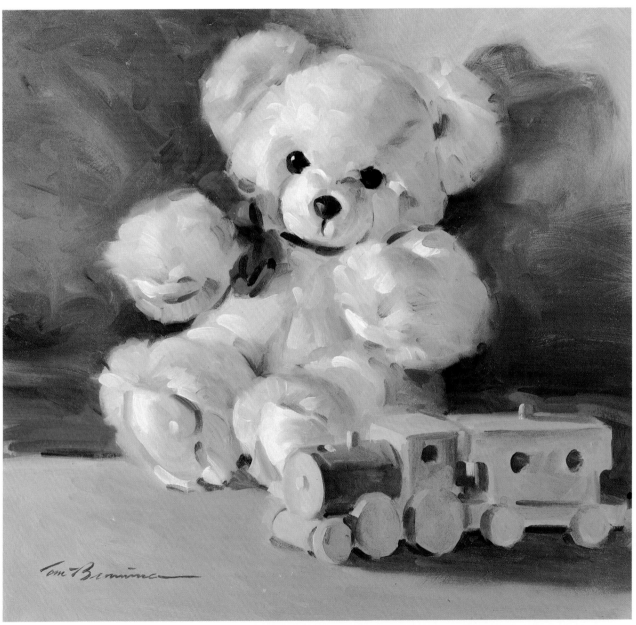

TOM BROWNING
Christmas Teddy
Oil on panel
15" × 14" (38cm × 36cm)
Collection of the artist

I did this little painting several years ago. It was done strictly for practice and pleasure, but I remember very well how the shadowed side of the bear needed to be exaggerated a bit. The contrast from the light side to the dark side was so slight that if I looked too long and hard it seemed to disappear altogether. Glancing briefly at my subject gave me a quick impression by which to establish my value relationships.

Light on Spheres

The planes on a cube clearly demonstrate the way light is abruptly diverted by the sharp angles or planes. But on a sphere, the light appears to glide smoothly over the surface until it continues past the object. As a result, the change in values from light to dark is softer and more subtle than on a box.

But let's imagine a sphere that is broken into vertical planes, like the globe at right. Though the angles of the planes are slight, they are still there, resulting in abrupt value change as light passes over the orb. With these planes it's more evident how light falls on a spherical form.

Although it has no angles like the box, the ball still has an area of its surface that is perpendicular to the light. This will be the area of lightest value. As the light strikes this spot head on, it appears to disperse itself over and around the form until it passes on to illuminate the tabletop around the shadow of the sphere.

At the point where the light leaves the sphere you will see the darkest value. This darkest dark usually appears where the light, unable to bend, leaves the surface of the object and the shadow begins. Sometimes called the core of the shadow, this dark area progressively gives way to lighter value as the shadowed plane picks up light from surrounding sources. This could be considered the end of the shadow.

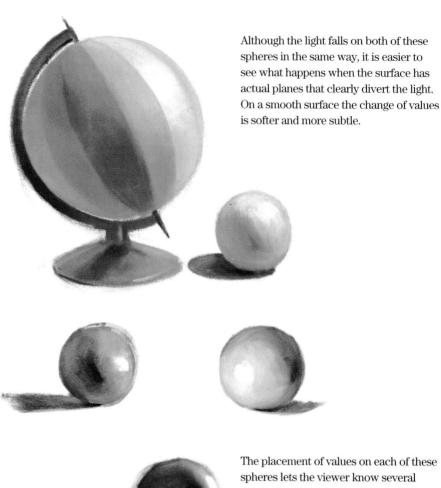

Although the light falls on both of these spheres in the same way, it is easier to see what happens when the surface has actual planes that clearly divert the light. On a smooth surface the change of values is softer and more subtle.

The placement of values on each of these spheres lets the viewer know several things about the objects: Their shape, general surface texture and, of course, direction of the light source.

Light that bounces off the reflective surface of the tabletop becomes reflected light. This secondary source of light then lights up the underside of the ball. If the ball was sitting on black velvet, the light would be absorbed and reflected light would not exist.

Original light source

Shadow core

Reflected light

Reflected Light

Note that although the shadowed side of the sphere in the sketch at left consists of one-half of the sphere, the outer edges of this shadow become lighter in value. This reflected light comes from the table surface as well as from light bouncing off the background surfaces.

Reflected light is important to detect and add to your painting. It not only helps identify the shape of an object, but also adds realism. Reflected light describes the way light falls over an object and bounces back into it. If it's actually there, it's best to put it in. Reflected light can keep a rounded surface from looking flat and add interest and excitement.

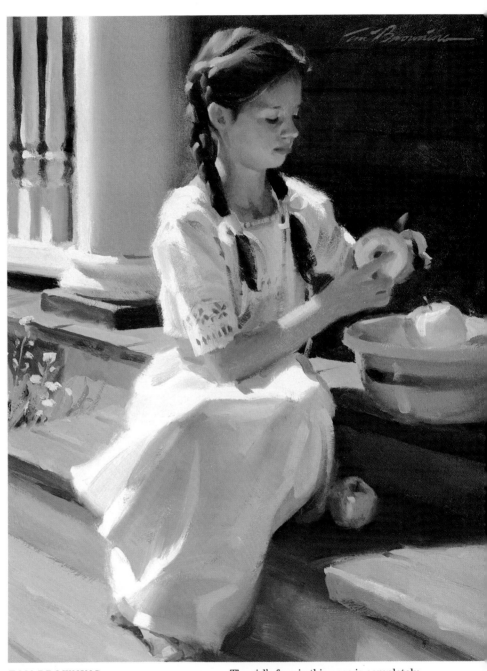

TOM BROWNING
Lillian
Oil on panel
14" × 11" (36cm × 28cm)

The girl's face in this pose is completely turned away from the source of light. However, the sunlight bounces off the white of her lap and illuminates the underside of her face with a warm glow. Even the column behind her is receiving reflected light from her back.

Painting Light on a Sphere

This next exercise in observation is similar to that using the box with the exception that there are no sharp angles to separate values. They flow into one another with a smooth transition that helps to identify the object as a sphere.

Find a round object such as a cue ball, an orange or a baseball. Anything round and of one color will do. Like the box, place it on a table with a single-light source. Again, with black-and-white paint and your growing knowledge of values, match with pigment that you see on the table.

I suggest you move the light and repeat this exercise a few times to further strengthen your observation abilities. Then try putting a dark background behind the subject, not letting any light fall on the background so it will be as dark as possible. Note how your job of comparing values has changed with this new contrast. It also creates a stronger visual impact, which I'll discusss at length later.

Again, match the values and be sure to include the background. When you've finished, move the light and repeat the procedure. Don't spend a lot of time on this unless your time is spent repeating the exercise over and over. I would say ten to fifteen minutes for each one should be a good time limit to consider. Although it might seem tedious, this will shorten your painting time in the long run. You'll be able to observe, match values and establish your overall painting quickly and more accurately. When comparing, remember to glance at your subject rather than stare. There are times when looking long and hard at your subject is necessary, but not for comparing values. Trust me.

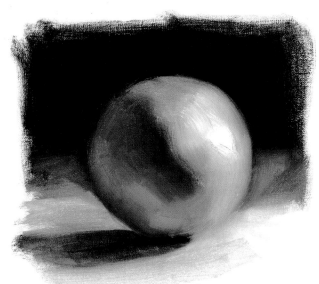

By adding a dark background, seeing values and translating them is actually easier because of the contrast that is created.

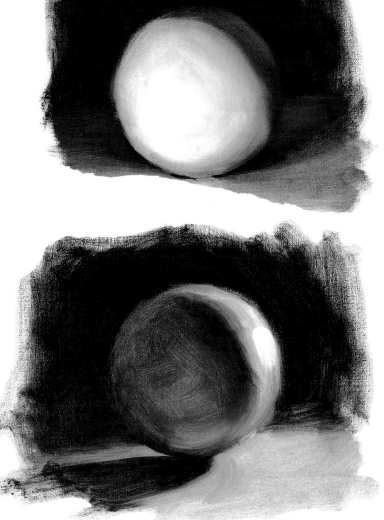

18

Light on Multiple Planes

Students often get confused by objects that have a multiple-plane surface, such as the human head. To simplify this idea, let's return to the basic cube.

Take two boxes of the same color and stack one on top of the other so they are not aligned. Give them a single-light source and observe how each of the planes you see is a different value. Now, instead of having three values (as with one cube) you have an additional two. The tops of both boxes should be the same value since they are receiving only one light source from the same angle.

When painting your planes, remember to look for subtle changes in values, such as reflected light and shadow cores. And remember to compare the planes on your canvas with each other as well as with those on your subject.

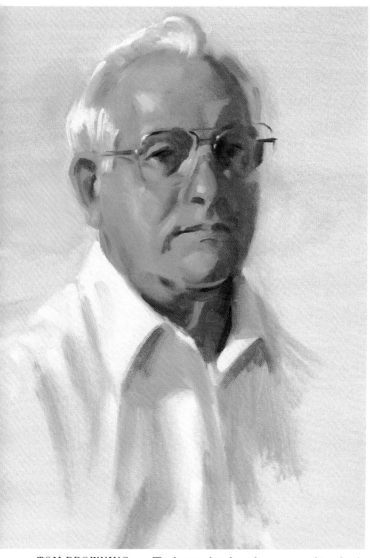

TOM BROWNING
Charley
Oil

The human head can be compared to a basic sphere or cube. With a single light source, all of its planes, bumps and dips are revealed, making it a little more complex. But remember that each feature is simply another form, and each change in values is relative to the light.

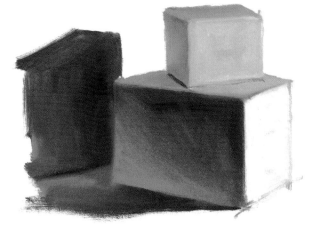

The more angles that exist on an object, the more values you will see.

The simple shape at left is not much different than a cube or a sphere. With two values only, you can establish the dark side and the light side. Then add the darker value in the center.

You can see how the light falling on the individual bumps and dips dictates the changes in values of the object below. By adding these few values, the subtle variations in the surface appear. With this solid foundation of form, more detail can be added or it can be left alone. Either way, the viewer knows exactly what they are looking at.

Controlling Light and Values

TOM BROWNING

Before delving into color too deeply, I'd like to summarize what I've discussed to this point about light and values by way of a simple demonstration. I've chosen a subject that has a limited range of color, so I'll take advantage of a limited palette. In the next chapter, I'll discuss the other two dimensions of color (hue and intensity) and incorporate them with values to show how they all relate to one another.

1 BEGIN WITH THE BASICS

In this first step, I began to establish the basic components of the composition and a rough idea of value relationships. After toning the canvas with a thin wash of Ivory Black and Yellow Ochre, I sketched in the placement of the objects. Then with a mixture of Viridian Green and Cadmium Red, I established the forms of the objects by painting in the shadowed side of each object and the shadow it cast. These value patterns represent the skeletal structure of the painting.

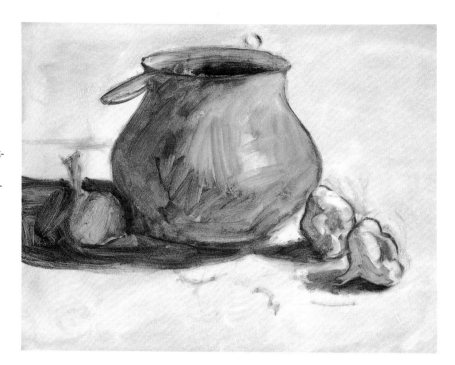

2 DEVELOP THE VALUE RELATIONSHIPS

Before doing any more work on the objects themselves, I wanted to develop more value relationships to use for comparison. So I painted in an approximate value to represent the background using a thin wash of Ivory Black, Yellow Ochre and Viridian Green. I then quickly covered the foreground with a thin wash of Yellow Ochre and Cadmium Red. Although I knew that most of these values would be painted over and adjusted, I now had a basis for comparison on my canvas. I could begin to bring the picture up to its proper values by comparing one area with surrounding areas.

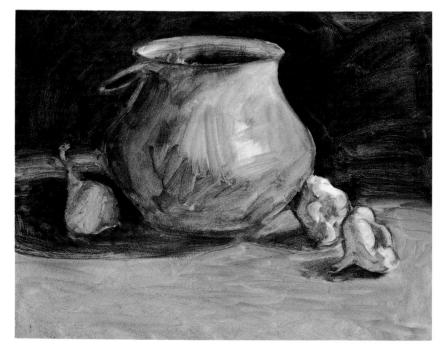

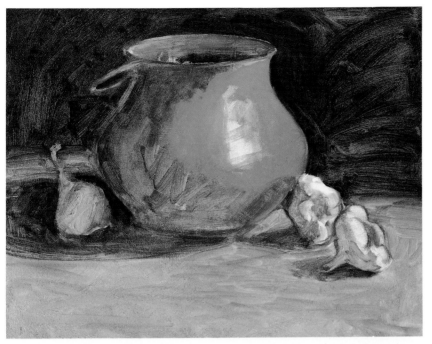

3 DEFINE THE LIT AREAS

At this point I began to define the lit area of the copper kettle. I could have begun just as easily with the shadowed area, but I wanted to get a suggestion of color into the picture. With mixtures of Viridian Green, Yellow Ochre, Cadmium Red and Lithium White, I painted in the area of the kettle that was receiving light.

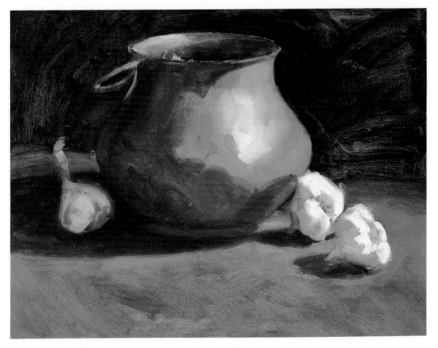

4 RETURN TO THE SHADOWED SIDE

Using Ivory Black, Viridian Green and Yellow Ochre, I went back into the shadowed side of the kettle to establish a more accurate value relationship with the lighted side. I then worked on the garlic with the same approach as the kettle. I painted on the light sides, then adjusted the values of the shadowed sides. Then with a little thicker paint than the original wash, I adjusted color and value in the foreground.

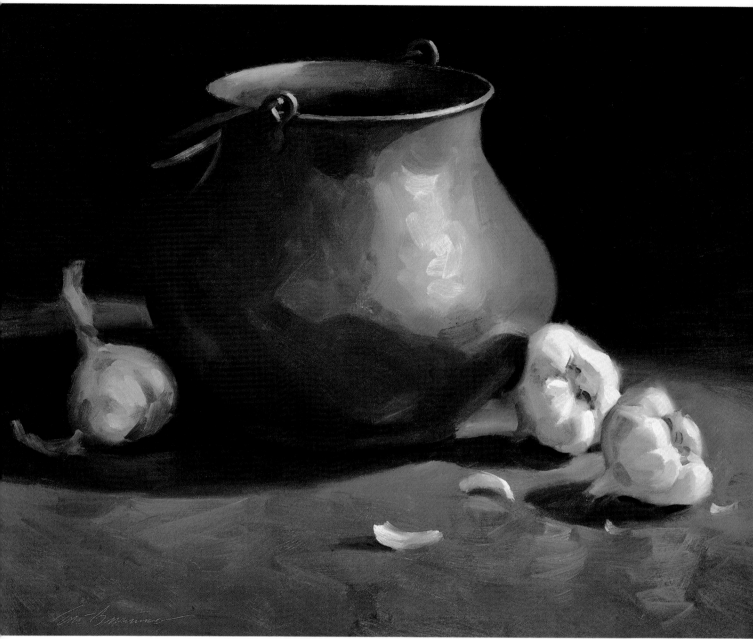

TOM BROWNING
Copper Kettle
Oil on panel
14" × 18" (36cm × 46cm)

5 FINISH

At this point I stepped back and saw that most of the hard work had been done. All that remained was to refine the edges, finish detailing and adjust color and value. This pulling-together process is what gave the painting a more finished look.

The background needed a darker, richer look, so I added Ivory Black, Viridian Green and Yellow Ochre to give the kettle more prominence. Details such as the hooks and handle were added, and more color was put into the lit side of the kettle. Although the shadowed side of the kettle was picking up a lot of reflections from around the room, I chose to eliminate those and keep the values relatively close together. A suggestion of reflections on the tabletop and a few pieces of garlic skin completed the picture.

A Four-Step Summary to Seeing Values

There's a lot to remember about how to observe value relationships and how to translate the values into a modeled form. Eventually it becomes second nature and, once it does, painting whatever you want becomes much easier. Here are some helpful hints to keep in mind while you are learning to control values and light.

1. USE A SINGLE SOURCE OF LIGHT

Try to stick with one light source on your subject. If you have more than one for a desired effect, be sure that one dominates over the other. Too often I see struggling students referring to photographs that have been taken under multiple-light sources, but trying to paint as if there were only one. They become lost and confused because the values in their reference are not correct for having one light source. Unless you fully understand how light falls on the form you're trying to paint, the values will not be correct. Therefore, their forms will not be convincing. And remember, the surface most perpendicular to the source of light will have the lightest value.

2. ALWAYS COMPARE

From the very beginning to the final stroke of your painting you must constantly compare values and their relationships with surrounding values. After a few strokes of the brush, step back and compare the colors and values on your painting with those of your subject. Try glancing at your subject then quickly looking back at your painting to make this comparison. This is the best way to see whether or not you are headed in the right direction.

3. SQUINT YOUR EYES

Although I've suggested glancing at your subject quickly for the impact of a first impression, observation is necessary, as is a little analyzing.. Another way to reduce the amount of entering light your eyes is to squint your eyes down to tiny slits. This reduces all the details in your subject, letting them dissolve into the main masses that you should be most interested in capturing at the beginning. When you want to add more detail, just open your eyes a little wider and they will be there for you.

4. SIMPLIFY MASSES

Many paintings are ruined with unnecessary detail that could have just as easily been left out. Details are fine, but take care that they don't break apart the masses or patterns that are needed to let a painting look as strong from fifty feet away as it does from five feet. Remember to keep the values in a single mass close together and to a minimum.

Tonal Values in Drawing

Values play a dominant role in the harmony and design of your composition. A large dark area in the foreground can be balanced by a properly placed, small dark area in the distance. Value contrasts can create your center of interest simply by having a light area surrounded by a dark area, or vice versa.

Seeing values correctly will help you interpret the atmosphere and colors of nature—the greens and blues, etc.—into black, grays and white in order to render a believable drawing in pencil or charcoal. When you look in the distance, you can see that mountains, trees, houses and other objects are much lighter than objects in the foreground. This phenomenon is caused by dust particles in the air that diffuse the colors of sunlight, giving a lighter blue-gray look to objects in the distance.

To the right is a value scale showing four shades of gray plus black and white, which should be enough values for you to start with. There is no rule on the proper number of values to compose a picture, but I suggest you start with no more than this amount to keep things simple. If, as you progress, you find that you would like to work with more values, do so.

Below is a photograph of a typical landscape with boxes of gray values plus black and white. These indicate how you might convert the greens, browns and blues of nature into grays, blacks and whites. If you look closely at the photo, you'll see that I could have added more grays to encompass more of the values that are visible in the picture. But the object is to say more with less. Remember that you are creating a drawing, not duplicating what a camera can do.

The artwork on pages 24-27 was created by Stanley Maltzman.

Seeing Values

Compare the value boxes in this photo with the value scale (above right); you will see that the values are the same. Once you develop a value scale, try to stay within those values. It will make drawing outdoors a lot easier.

Translating Value Sketches

If you squint your eyes or use amber-colored sunglasses, you can break down the landscape to about three values—a light, a medium and a dark. In the beginning, most people tend to overestimate the number of values they see in the landscape. Naturally, there are more than just three values, but the simpler you indicate your sketch, the easier it will be to translate your value sketch into a drawing when you get back to your studio.

Using the value scale on the previous page, make a simplified line drawing of the scene before you (as shown in sketch A). Then indicate the values using a numeral or a letter to key one to the other. The basic rule is to simplify.

Sketch B shows how your value diagram translates into a value sketch, using just the limited six-value scale. Compare this to the finished drawing at bottom.

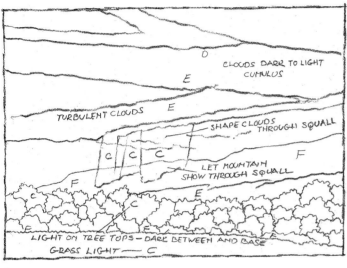

A

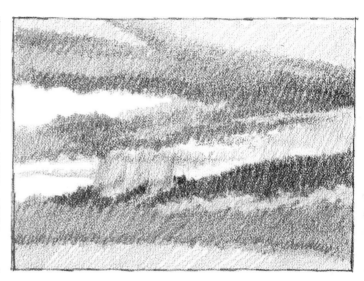

B

STANLEY
MALTZMAN
Mountain Squall
Graphite on
Strathmore 2-ply
bristol
4½" × 6½"
(11cm × 17cm)

The finished drawing shows the values and details that were added with the help of my two sketches and memory.

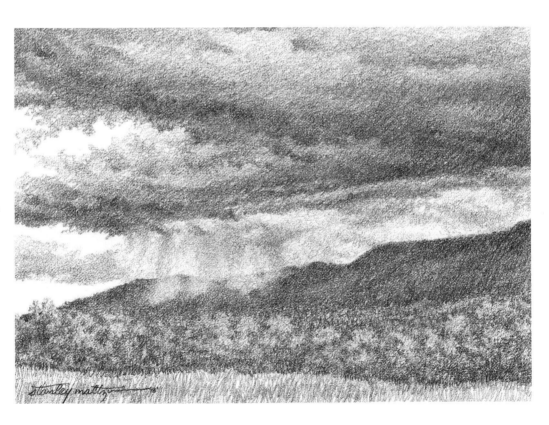

Foreground, Middle Ground, Background

In the previous pages, we discussed seeing values and translating values from nature to your drawing. Now I would like to introduce you to the three "Gs"—foreground, middle ground and background. Most landscapes have all of these in their composition, and they may vary in any imaginable combination.

In the examples below, the hay bales and grass are the foreground, the trees and mountain are the middle ground, and the sky is the background. Look them over and see if you can pick out the three major values—light, medium and dark—in the foreground, middle ground and background. The scene is the same in each example, but as you can see, you can create various moods, weather conditions or times of day just by changing values from light to dark.

Now is the time to make thumbnails to help you decide the placement of values in your foreground, middle ground and background; what will dominate your drawing; and what combination of values will tell your story.

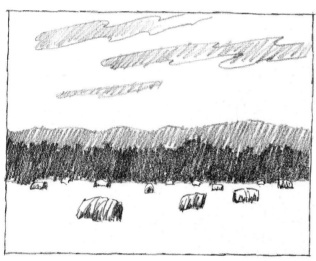

A In sketch A, there is a predominance of light values in both foreground and background, creating what could easily be a bright summer day.

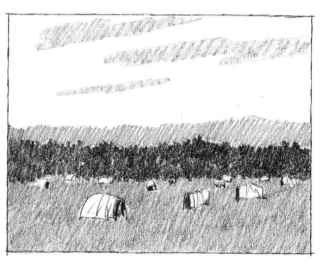

B Sketch B tells you that it is still a bright day, but more toward late afternoon. Notice that the lighter-value bales of hay have become more prominent.

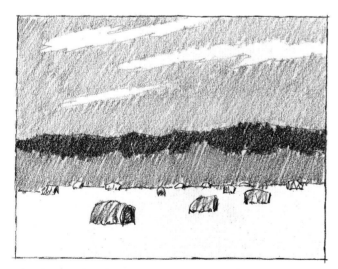

C A value placed in the sky changes the placid summer day of sketches A and B to a possible storm approaching, or to late afternoon.

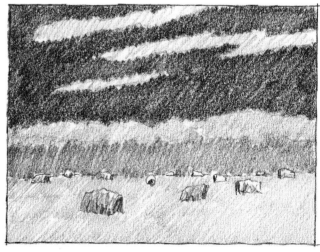

D Dusk is upon us. In all four sketches, my three "grounds" remained the same. Only my values changed to create various times of day and different atmospheric conditions.

In the drawing below, *Round Bales*, I have conveyed—through the proper use of values and placement of foreground, middle ground and background—a sense of a hot summer day, which is usually found around haying time. Thus my picture has a truth about it and is believable.

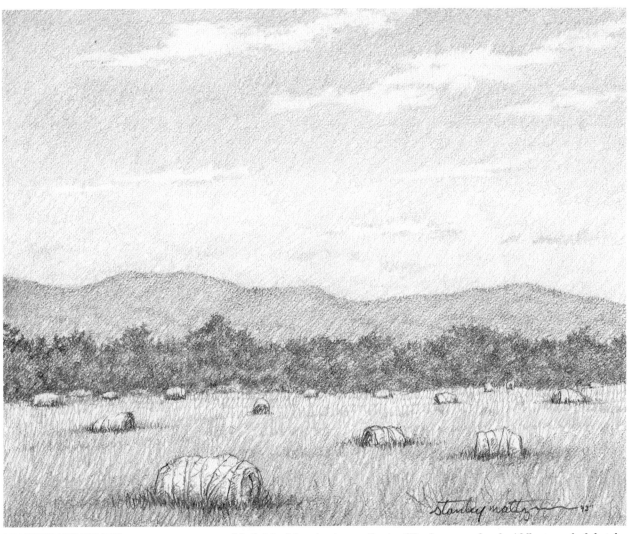

STANLEY MALTZMAN
Round Bales
Graphite pencil on Strathmore 2-ply bristol
5½" × 7" (14cm × 18cm)

My finished drawing is a synthesis of the foreground and middle ground of sketch B with the background (sky) of sketch C, which I felt would better create the mood of the day.

Important Middle Values

Although just dark and light values can show basic shapes, it is only through the addition of middle values that full form is depicted. On a tonal value scale, the extreme values of black and white are at opposite ends. The transition or change between them makes up the mid-range. Thus the middle values identify and show surface form by the way they reveal changes between dark and light areas. Whether a surface form changes gradually or quite suddenly depends on a middle value to show what happened.

The middle values also act as a unifying factor by holding together the multiple complex dark and light areas present in many subjects.

Using middle values in the beginning of a painting makes it easier to hold the painting together. As shown below, the deepest darks and strongest lights can be kept out of a painting until much of the form has been developed using middle values.

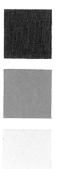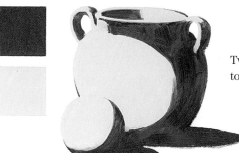

Two values of dark and light are insufficient to depict true surface form and depth.

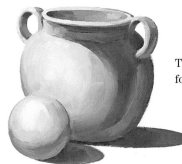

The middle values make it possible to show form and depth.

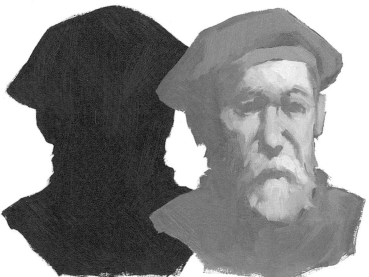

1 When you start a painting, stay with the middle values, avoiding the contrast between deep darks and strong lights. You can develop much of the basic form using good edge control. The painting will hold together and corrections can easily be made.

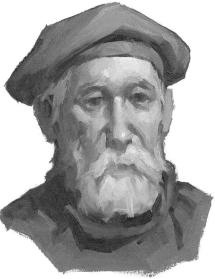

2 Only after you have developed all of the basic form with the middle values should the deeper darks and stronger lights be added. It doesn't take much more value contrast to give the appearance of full form and depth.

The artwork on pages 28-37 was created by Ted Smuskiewicz.

Building Form With Value and Edges

Two important elements work together to fully develop a painting full forming of a painting: value and edge control. First, a good dark and light value construction must show a definite light source and its effect. Next, edges must not only act as boundaries between different areas of a picture but must also show divisions or changes in surface form. The way two colors or values come together tells us about a surface. This information is necessary in order to recognize form. Some edges separate two areas that are so close in color or value that the exact boundary is difficult to see. In this case the edge becomes lost. While the exact edge itself is important, so are the surface color and value just before that edge is reached.

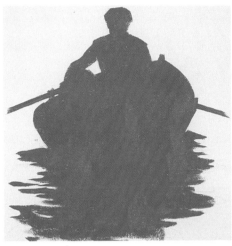

1 Use a middle value to paint the basic shapes of all the individual forms, combining them as one unit. At this stage, the outer edges are important for showing form. Although there is no modeling with other values, you can still recognize the subject as a person in a boat.

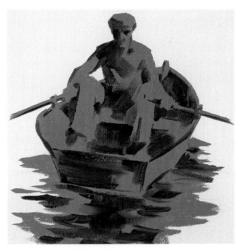

2 Paint the dark areas to indicate the separate forms that make up this subject. Most edges are similar, and there is very little modeling with any other value. Now you can recognize individual parts of the subject.

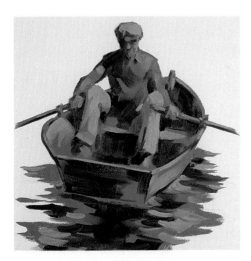

3 As soon as you add in the lighter value, a full form begins to emerge. The edges are clarified so that a clearer form and a definite light source is established. Your subject now takes on depth and dimension.

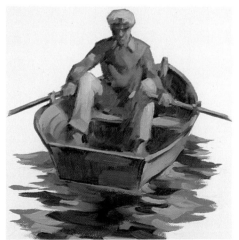

4 More subtlety of values and careful treatment of edges develop your picture to a more complete appearance, demonstrating the full effect of form and light.

Tonal Value Arrangement

Of all the different things that make up a painting, the placement of dark and light values at the beginning is one of the most important. When I paint, I use this first placement or arrangement of values to guide and help me in developing the painting. The tonal value arrangement also helps me to express my feelings about a subject in the way that I put together or balance all these different values. Different ways of seeing a subject require different ways of putting together values.

In order to use this first value arrangement as an effective guide, all the different values that make up a picture must first be reduced into two simple divisions of dark and light. This means that somewhere along the value scale a division is made; and all the values on each side are combined into two separate groups, one dark and one light. This division usually occurs somewhere in the middle-value range.

Squinting at the subject being painted is a very effective way to visualize this first grouping of values. Remember, when you squint at something, all the different values and colors are reduced into a simple value arrangement. Being able to see and use value in this basic way makes it easier to start a painting.

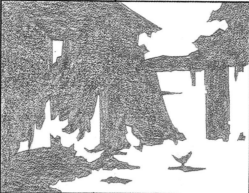

This painting was first reduced to a simple dark-and-light value construction. I divided the full range of values into two simple groups of dark and light by combining values.

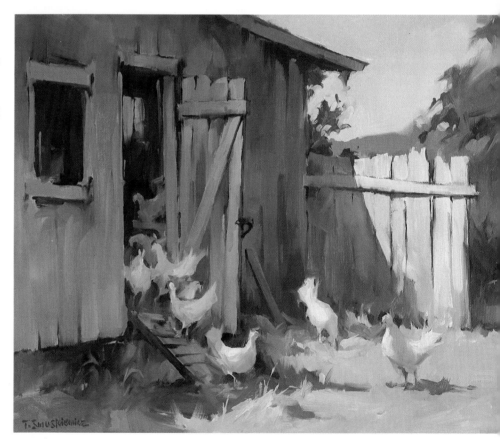

TED SMUSKIEWICZ
Chicken House
Oil
12" × 16" (30cm × 41cm)

THE ENCLOSING PICTURE RECTANGLE

When something is placed within the borders of a picture, it reacts immediately with the various areas of space created by its placement. Anything that is placed inside this rectangle will be affected both by the enclosing borders and by the other things that are already there, yet the rectangular border is the main element that everything in the picture balances against. Therefore, the first step in arranging or composing a picture is to establish the enclosing borders.

Another important use of picture borders is to limit our view of what we see. When we look at something, it is easy to be overwhelmed. By looking through a viewfinder that acts as the enclosing borders, it becomes easier to concentrate on certain things and balance them against each other. Good composition requires careful selection and placement of a subject within these borders.

The enclosing picture borders give a limit for something placed within to balance against.

When another element is placed in the picture, it balances against the enclosing borders and against what is already there.

1 Place the first darks near the lower side of the enclosing rectangle, creating a heaviness at the bottom.

2 Place darks in the upper-right corner to help balance the original placement.

3 Simplifying complex value arrangements into basic groups or divisions of dark and light helps you successfully place subjects within the enclosing borders.

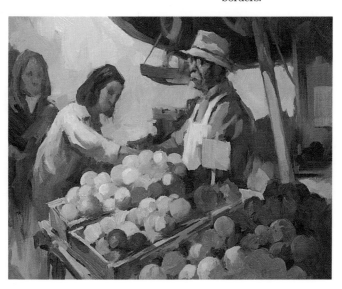

DARK AND LIGHT DISTRIBUTION

In my painting, the first placement of dark and light values is very important to the development of my ideas. In order for this to be done, all the different values that will make up a picture must first be reduced to simple divisions of dark and light. That means dividing all the values into two separate groups. As individual parts of a subject begin to combine with other parts that are similar in values, a massing or grouping together occurs. By distributing these dark and light masses throughout the picture area, a visual effect or appearance is created. This first dark and light distribution has a strong influence on the feelings depicted in my painting.

The mood and feeling that I want to show are created by the way I place these dark and light areas against each other. There are two basic placement—or distribution patterns. In one, the lighter values seem to connect and hold together. In the other, the darker values connect and flow together. Another important consideration when developing a value distribution pattern is the size of the area that each separate group covers. For good balance and feeling in a picture, make sure that either the dark or light areas occupy more picture space.

The lighter value mass is more connected and covers a larger area than the darks.

Darker values mass together in a connecting pattern and occupy a larger area than the lights.

The different values are first combined into separate groups of darks and lights. This basic distribution pattern has a strong influence on the painting's final appearance. Notice that the darks occupy more of the picture's area and that they are more connected than the lights.

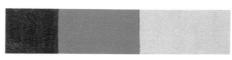

As the middle values are put into the picture, more depth and space is obtained. Attention to the edges and to the modeling of forms with value changes begins to develop more parts in the picture. However, the underlying dark and light distribution is still visible.

BALANCE

Anything that is put inside the borders of a picture is immediately compared with other things already there. Comparing how different things appear when they are placed together is the basic method of balancing used in painting.

When darker values are introduced into a lighter painting, the added contrast of the darks complements the lighter values, making the picture appear even lighter. If everything is the same value, there can be no balance. Good balance requires contrast. For instance, dark values are balanced against lighter values, harder edges are contrasted with softer edges, and complex tonal arrangements are balanced against simple flat value areas. The balance of opposite or contrasting colors is also an important principle. For good balance, unequal and contrasting elements must be placed together in such a way that they complement rather than cancel each other.

In addition to these general principles, good balance in a painting is also achieved simply through exercising your own judgment. Our personal feelings and preferences influence our judgment. After all, they do reflect how we see life. Be honest; always trust your own judgment and feelings about your subject.

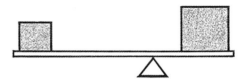

Equal sizes and weights balanced on a lever with the fulcrum in the center give a stable but static appearance.

The picture on the left is a static arrangement that lacks interest. By making things unequal in size and placement, a better balance is achieved. A good picture balance always needs contrasting and unequal shapes to complement each other.

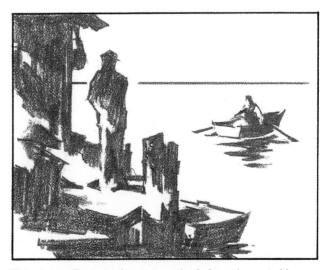

Unequal sizes and weights balanced on a lever with the fulcrum well off-center give a more dynamic appearance.

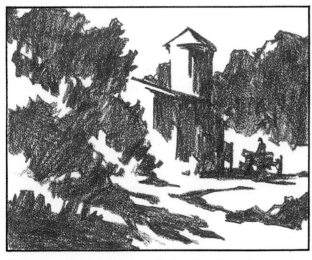

Using unequal areas of dark and light values is another way to create interesting picture balance. The principles of contrast and unequal divisions and sizes are applied here. In this picture the dark areas are much larger than the lighter areas and are also connected throughout the composition.

This picture illustrates how interesting balance is created by contrast and unequal divisions. The smaller boat out in the open balances and complements the larger and more solid dock area.

The Effects of Tonal Arrangements

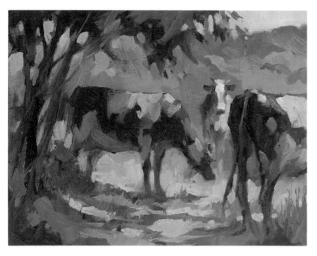

When I start painting, I am very aware of the emotional response and feeling that a subject gives me. Controlling the shape and size of the different values or tones helps me express those feelings through the painting.

Although the darker tones are very influential in this picture, there are enough middle and light areas to give a good balance and show sunlight and shadow. The cows among the trees in a sunny pasture suggest a quiet and peaceful setting, but the strong contrast of dark and light in many places also gives this picture a dynamic effect.

This is a much darker value arrangement. Darker values dominate in the picture, giving it unity but also a certain heaviness. The darkness of night seems to weigh heavily on everything. However, the subject itself and its strong light effect give this picture vitality and interest. Painting a night scene still requires a good balance of different values. To show the dark night effectively, some light must be present to contrast the darkness. No matter what kind of value arrangement is used, there must be enough variation in values to give contrast or balance to the picture.

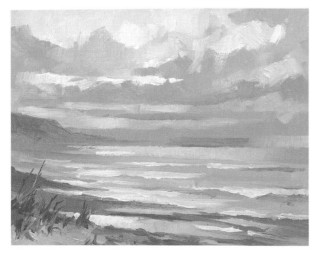

Lighter values predominate in this picture, giving it a restful and calm visual effect. Notice how the values become lighter as they recede into the background. This is a basic principle of achieving depth in a painting. Here, all the values have been shifted toward the lighter side of the value scale to achieve a light and airy effect. The middle values unify this picture by appearing throughout the composition as part of an overall pattern.

Tonal Arrangement

The first part of this project is about learning to arrange or compose dark and light masses in a picture. We will start with a simple exercise that will help develop your ability to balance and arrange these masses. For this project, you will use some white drawing paper and two drawing pencils, a hard 2H and a soft 2B. While you are doing this exercise, keep in mind that good balance and arrangement in a picture requires the use of unequal divisions and sizes. Repeat this exercise often to develop a good sense of picture balance. Save some of your better results for future use.

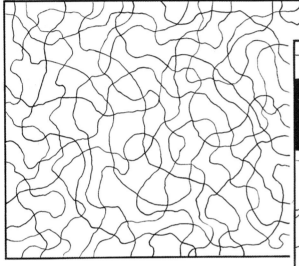

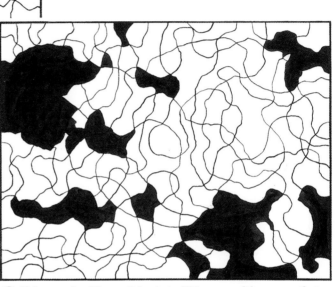

1 Draw a picture rectangle five or six inches long on white drawing paper. With a sharp 2H drawing pencil, start at one side and draw lines that wander almost aimlessly until they touch somewhere on another side. Keep drawing lines that go in different directions and continually cross over previously drawn lines. Make sure you fill all the empty spaces and keep your lines lightly drawn.

2 Using a softer 2B pencil, begin to fill in some of the spaces that the first lines enclose with a solid dark tone. Do this in a random way. Start with several small dark shapes, then connect some of the shapes together to form larger shapes.

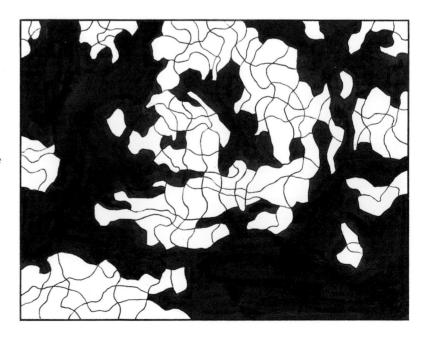

3 Begin thinking about balance and enlarge or add other dark shapes by filling in more of the lines, using the principle of dark and light distribution. Keep the dark shapes uneven in size and shape. Connect some shapes together to form larger masses; try to establish connection and movement throughout the picture. For good balance, make sure either the dark or light masses predominate.

Develop this dark and light pattern without thinking of any form or subject. First achieve an arrangement of dark and light values that has a good balance and feel, then begin looking for a subject in it.

Making Use of Middle Values

Now we will do two exercises using the middle values. An arrangement of dark and light shapes can be pulled together by connecting them with a middle value. In addition to unifying a picture's darks and lights, the middle values make it possible to use full modeling of form.

Part One: Practice this exercise with pencil on white paper. First, put down some dark shapes separately inside a picture rectangle in a pleasing arrangement. Then introduce middle values to form a connection between the shapes.

Part Two: For the painting project on the next page, premix three values—

a light, middle and dark—using Burnt Umber and White oil colors. Before starting the painting, practice your brushwork. Try to control your brush, holding a strong edge and gradually

changing a value from dark to light. Limit your brushstrokes and wipe your brush regularly.

Lay out the darks and lights, then add the middle values to tie it all together.

PART ONE

1 On white paper, draw a rectangle and place some dark shapes in it using a 2B pencil. Make a pleasing arrangement of separate shapes of varying sizes.

2 Lay in a middle value that connects and holds the dark shapes together. Leave some of the paper white for good balance.

PART TWO

Premix three values of color using Burnt Umber and White for the project on the next page.

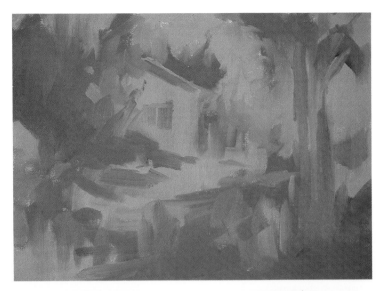

1 Use one of your better dark and light arrangements from part one on the previous page. With the middle and light premixed values, lay out the dark and light pattern on a panel approximately 12" × 16" (30cm × 41cm). If the value pattern suggests some subject or form to you, start putting it in the painting. Use your imagination. You will be painting wet-into-wet, so wipe out your brushes frequently.

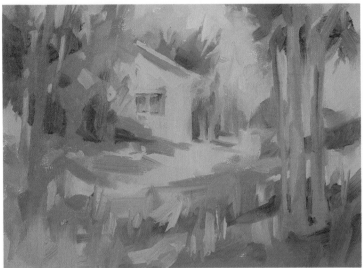

2 Emphasize the dark value now. Think of what kind of form or subject you are painting and try to develop it with some definite edge control. Some areas will require some overpainting and changing. Do not overbrush; leave your brushstrokes alone when trying for a sharp edge.

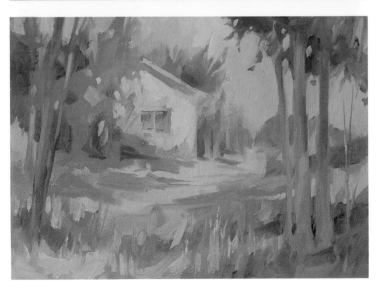

3 The underlying dark-and-light pattern should be retained as you add the middle values. In this project, the important thing to learn is how to keep the underlying value pattern or structure in the painting until it is finished.

Using the effects of light and of grouping different things together into masses of dark or light allows you to build your painting in a unified way.

Understanding Contrast

After designing the best possible shapes and determining their relative sizes and positions in the painting, the next critical decision is how to make the shapes visibly clear to those who'll be looking at the painting. The word "reads" has been coined for this purpose. An instructor might say, "The shapes of this painting 'read' clearly." Shape clarity is the result of contrast—contrast of value, pattern or color. It is important to remember that each of these three elements function independently. A shape created by value, such as a light shape surrounded by dark, reads clearly regardless of its color or pattern. The same is true of shapes created using color or pattern. A red shape against a different colored background is identifiable regardless of the pattern or value contrasts. Likewise, a busy, broken-up shape played against quiet, flat shapes maintains its identity regardless of the value or color contrasts.

It is equally important, however, that you understand the visual pecking order to the contrast level of these three elements. For example, if you create a shape that has equal contrasts of value, color and pattern, the contrast of value will be more visually apparent than the contrasts of pattern and color. If you make a shape in which value contrasts are eliminated and pattern and color are equal, you'll find that pattern is visually dominant over color. So the visual pecking order of contrast is value, pattern, then color. This should be important to you as a painter from both a technical and an expressive point of view. For if it's your intent to make a painting with an emphasis on color, and you fail to reduce value and pattern contrasts, you will produce a painting that is not about color at all. It will be a painting in which value and pattern have stolen the show, leaving color in a supporting role.

It is important that you determine which of these contrasts will dominate a painting. For if you don't decide and do a painting in which there is equal contrast of color, value and pattern, the result will be a work in which each contrast neutralizes the others. Great painters understand this and that is why they are great painters. Andrew Wyeth is a value painter. His paintings have reduced color and pattern contrasts. John Marin's work emphasizes pattern and has minimal contrast of value and color. Vincent Van Gogh and Paul Gauguin were in love with color and realized contrast of pattern and value would challenge their objective. What are your paintings about? Are you a Wyeth, a Marin or a Van Gogh? Not to decide is to decide!

The artwork on pages 38-45 was created by Skip Lawrence.

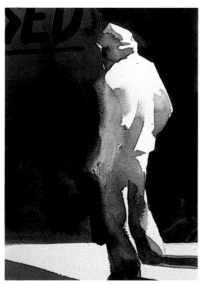

Value

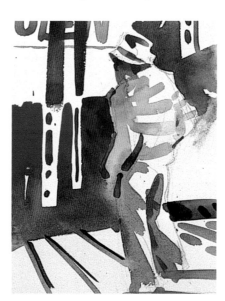

Pattern

Color

Value and Realism

Value painters tend to be representational painters. Their concerns are how light and atmosphere affect the value and color of objects in space. The study of these observations is called aerial perspective. While aerial perspective is not a science, it comes close to science, because the results of light on objects and on the landscape are bservable. These results do not call for interpretation or subjective reasoning. Objects that recede into the atmosphere appear lighter in value, cooler in temperature and lose their texture definition. All you have to do is remember a few simple rules, apply them to some interesting shapes, and success is yours. In the hands of the best and most experienced painters, the results of values and aerial perspective can be magical.

The effect of light hitting an object is another area where values reign supreme. Place a strong light on a red ball and observe how unimportant the color becomes. The lighted side of the ball is now a bleached light pink while the shadow side reads as dark purple or black. The trick to modeling the ball is not in the use of color but in showing the value changes from light to dark and the important transition between the two. Paint the ball half light and half black, and the ball will not appear round. The illusion is in the careful gradation of values from the light side to the dark. Look at the paintings of Rembrandt and see how much care he took to get from the highlight on the tip of the nose to the black background. These gradations are totally the result of value.

What the best value painters understand is that color only serves to confound the intent of the painting and that the less color the better. Study the painting of Andrew Wyeth and other value painters and see if you don't agree.

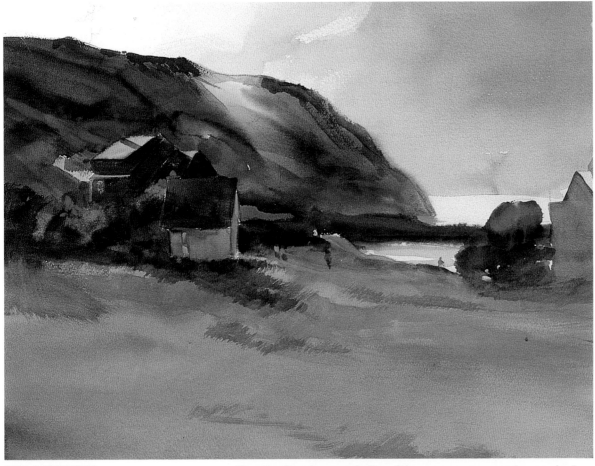

SKIP LAWRENCE
View of Monhegan 2
Watercolor
20" × 26" (51cm × 66cm)

Changing the value organization of the same scene reorganizes emphasis. It is a mistake to frantically search the world for ready-made compositions. It is better to explore the possibilities of one subject. In a seven-day visit to Monhegan, I painted this subject nine times.

Designing With Values

SKIP LAWRENCE
View of Manana
Watercolor
20" × 26"
(51cm × 66cm)

A decision of whether to design in value, color or texture should be based on the expression desired. In this case, I felt the best way to describe the fading light was strong value contrast. Notice how a change from value to color creates a totally different feeling.

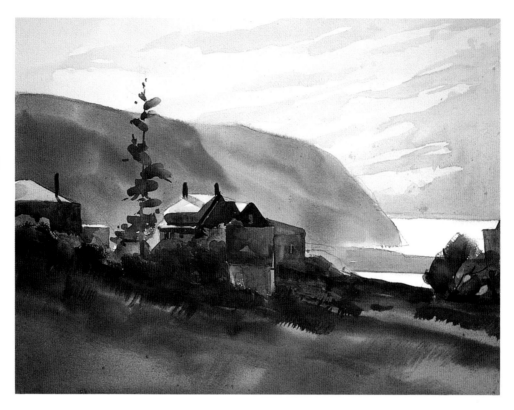

SKIP LAWRENCE
Greenville Fall
Watercolor
20" × 26"
(51cm × 66cm)

In spite of the abundance of orange, this painting is designed with values. Values are visually more aggressive than colors. It was my intent to first express the quality of strong light on a fall day. Had it been my objective to celebrate the colors of the day, I would have reduced the value contrast.

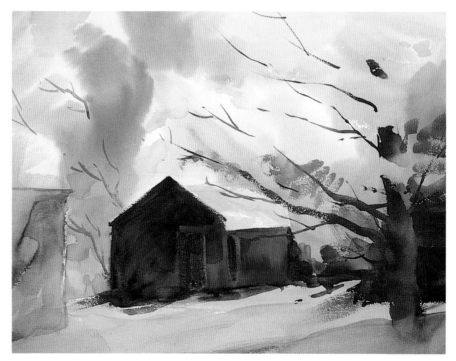

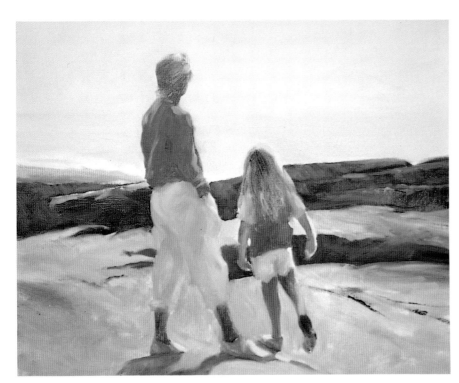

SKIP LAWRENCE
Shauna and Carly
Maine
Oil
16" × 20"
(41cm × 51cm)

A painting of my wife and daughter at Acadia National Park is a simple pattern of light, middle and dark values. The gesture of the figures coupled with love was my inspiration.

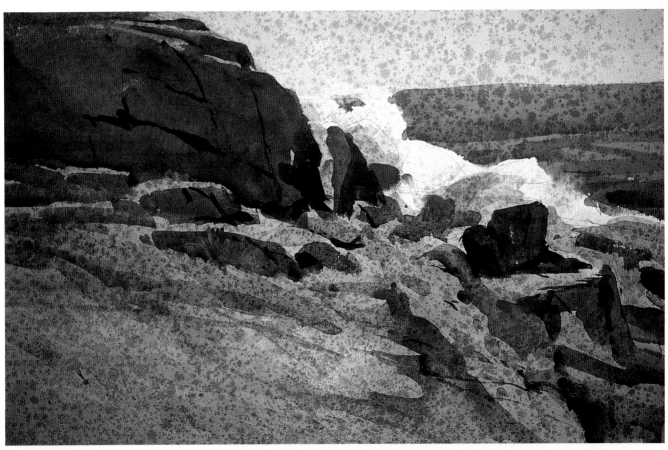

SKIP LAWRENCE
South End Monhegan
Watercolor
15½" × 22" (39cm × 56cm)

The stark value contrast of the rocks to the surf dictated a value painting. While color plays an important role, this painting could have been done in black and white. Imperfections in the paper (original Whatman circa 1940) created the interesting texture.

Organizing Value Shapes

SKIP LAWRENCE

1 CONCENTRATE ON THE LARGE SHAPES
A drawing should show evidence of your intent. I keep the drawing simple and am concerned only with the large shapes.

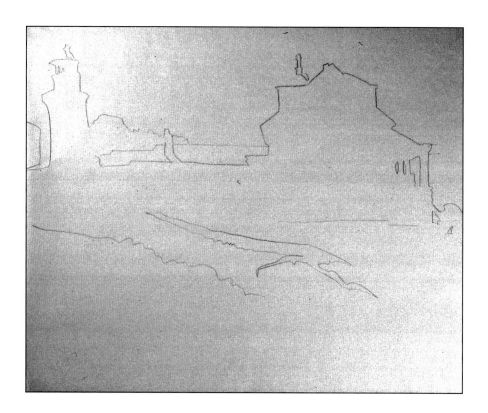

2 BEGIN TO DEFINE THE LARGE SHAPES
My initial washes describe the shape of lighthouse, lawn, rocks and trees all as one thing. I take advantage of this step to also determine the basic colors. In this case, I decided on cool pure tints accented with more intense warms on the face of the house.

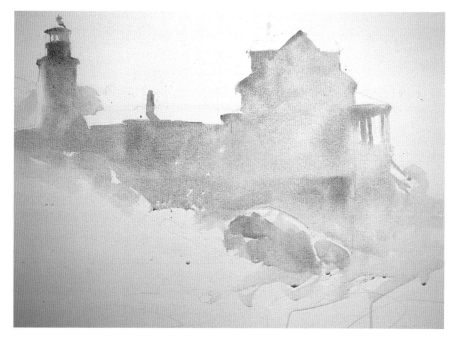

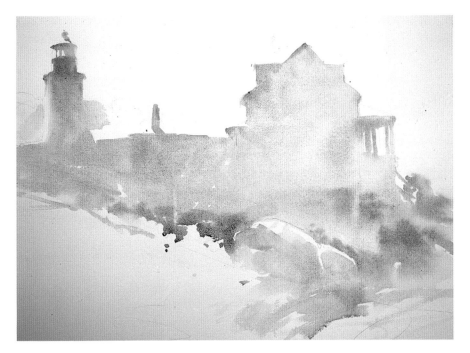

3 ADD COMPLEMENTARY COLORS

Complementary colors are dropped in to contrast with the cool pure colors of the large house shape. It is not my intention at this point to add details. My only thoughts are of subtle color changes. I avoid strong value contrasts and hard edges, which would only serve to draw attention away from the large shapes and delicate color contrasts.

4 COMPLEMENT THE LIGHT BY ADDING DARK VALUES

I selectively add a few dark values along the edge of the total composition. These darks serve to complement the light that dominates the painting and identify the position of the light source. The trick here is to see how many details you can leave out. I add a very light neutral wash to the sky to define the roof edge.

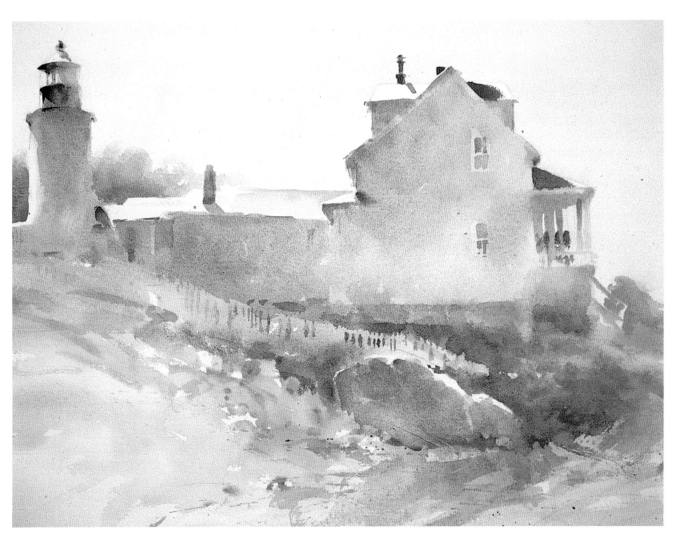

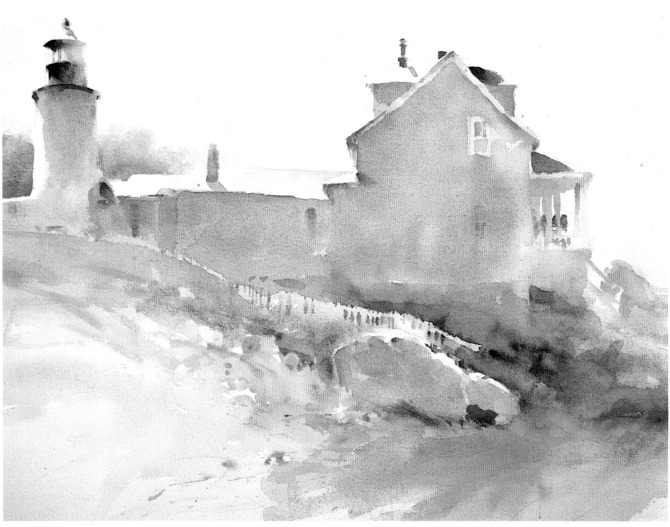

SKIP LAWRENCE
Permaquid Point Lighthouse
Watercolor
20" × 26" (51cm × 66cm)

One last wash of violet is necessary over the entire lighthouse shape to create a stronger feeling of sunlight.

SKIP LAWRENCE
On the Edge
Watercolor
20" × 26" (51cm × 66cm)

This was done from the inside edge of a cemetery looking out. There's something appealing about looking out of a cemetery, so I painted it. The shape of the trees and wall made a great pattern of middle and dark values. Beyond the wall there was light.

REMEMBER:
1. It is compositionally helpful to observe and design with value shapes.
2. Value organizations can be altered to suit your objective.
3. Reorganizing value patterns can identify focus.
4. Reserve a greater value range for the focal point.
5. Value shapes can be converted into color shapes.

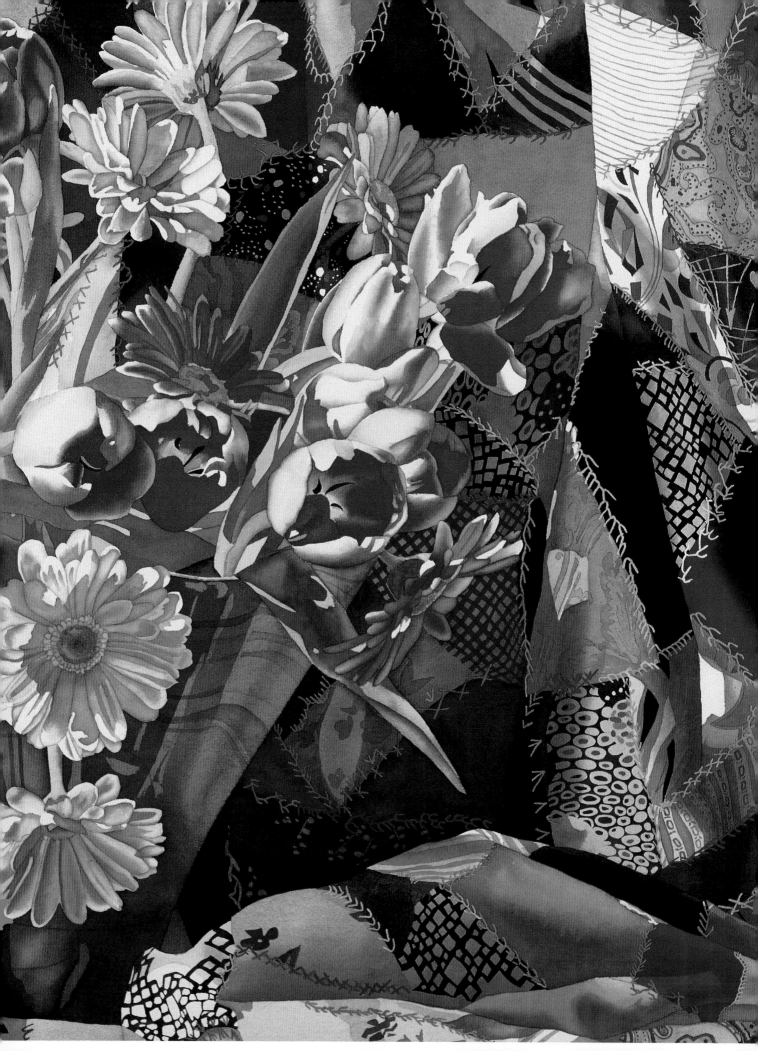

Color Needs a Foundation of Lights and Darks

Brilliant colors alone are not enough to make a successful painting. It is critical to provide an underlying framework for the brilliant colors in your watercolors, just as our skeletons give form to our bodies. You must plan your painting carefully so that you do not lose the impact of all the beautiful colors in a confused value statement. When you paint with soft, neutral colors, values are more readily apparent. However, when you paint with vivid colors, it is easy to confuse colors with values. The value statement is the arrangement of lights and darks and provides the basic design, or backbone, of your painting.

Values define parts of a painting with respect to lightness and darkness. Values give composition and design as well as a feeling of dimension and depth. Furthermore, values give a painting luminosity and brilliance. Values are especially useful in creating convincing shadows, folds and contours. You determine values either by choosing light and dark local colors or by placement of sunlight and shadows. A good painting combines the use of both.

SUNLIGHT AND SHADOWS

Sunlight and shadows create an arrangement of lights and darks without regard to local color. They give impact and drama to a piece of art, as well as defining the shapes of subjects and the design of the artwork.

For example, in *Grandmother's Treasures* (opposite) sunlight and shadows provide structure. The amaryllis blossoms are actually bright red, but they are painted in every value from white, where sunlight strikes them, to a very dark burgundy, in shadow. Make your shadow values a strong enough foundation to support all the brilliant colors you want to paint.

The artwork on pages 46-55 was created by Judy D. Treman.

JUDY D. TREMAN
Grandmother's Treasures
Watercolor
38½" × 27½" (98cm × 70cm)
Private collection

Strong Value Statement

My grandmother bought this tapestry for me to paint. I could not conceive any flower that could hold its own with the bold, busy design. But when I saw several red amaryllis blossoms, at once I knew I had found the perfect subject.

Squint your eyes and look at the painting. See how the amaryllis blossoms pop out from the busy background. This painting shows it is possible to use a medium value for the subject against a busy background of light and dark values. The key is that you see a *different* background value than the subject value.

Practicing With Sepia Tones

PAINT WITH INDIA AND SEPIA INK

I trained myself to see values and color temperatures by using both India (black) and sepia (brown) inks. I spent about two years creating artworks resembling sepia-toned black-and-white photos. By using black and sepia, and mixing the two together, your palette can have three colors—a cool gray, a warm brown and a black-brown mixture. There is an infinite range of values with these three tones. The advantages of using these inks are learning to see color temperatures and values, as well as how to apply paint without the confusion of color. Furthermore, as these inks do not lift when glazes are applied, I developed the highly refined glazing technique that is at the heart of my painting today. I still recommend this as the best way to learn watercolor.

As you gain confidence with the India and sepia inks, gradually introduce colors, beginning with one warm and one cool. Start with low-key (less intense) colors such as Burnt Umber and French Ultramarine. The purpose is to train your eye to not only be sensitive to values, but also to warm and cool colors. If you choose high-key (more intense) warm and cool colors such as Winsor Red and Winsor Blue, your painting will be more garish. This will be less helpful in training your eye to see values.

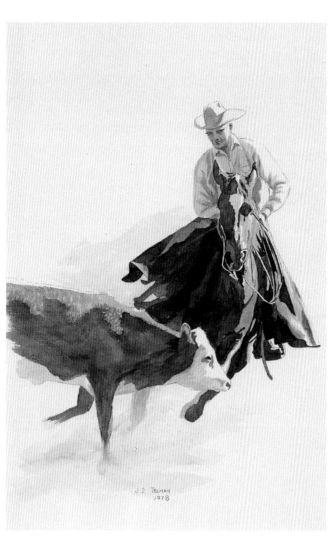

JUDY D. TREMAN
Determination
India Ink and Sepia Ink
12" × 18"
(30 cm × 46cm)
Collection of the artist

Value and Temperature

Working on tan-colored paper, I used sepia colors for warm areas where the sun shines, like the highlights on the right side of the horse. Gray tones, created from diluted India ink, define the cooler shadow areas, as on the white face of the calf. Dark values create simple, dramatic shadows.

Structure Watercolors to Emphasize Your Subject

To paint brilliant colors in watercolor, it is imperative to plan the painting ahead of time so that it will have structure and design as well as color. You cannot just start splashing glorious colors and hope for the best!

Before you paint, think about how you can use values to emphasize our subject matter and make it stand out against its background. You must deliberately make the subject a different value than the background so that the subject is clear to the viewer. Place light subjects in front of dark backgrounds or dark in front of light.

Consider the placement of colors in terms of values. You may have to change the color or shadow of either subject or background from what you see. Furthermore, it is not enough for the subject to be a different color than the background—it must be a different value as well. Squint your eyes and look at your painting. Your subject and background will blend together if they are the same value.

An artist once showed me a painting where the head of her subject appeared against a background of about the same value. If I squinted my eyes, I could not see the subject's head in the painting, although the body stood out plainly. If the artist had checked the values, she could have corrected this in the planning stage by making the subject and the background different values or by rearranging objects in the background so a different value was behind the subject.

A problem such as this is impossible to correct if you do not check the values until the painting is completed.

The following images show three different ways to use values to make the subject stand out from the background. You can make the subject darker in value against a lighter background, or make the subject lighter against a darker background. You can even make the subject a middle value against a light and dark background. The important thing is that the subject matter must be different in value than the background. Without the darks and lights playing off each other, a painting is meaningless, like trying to see a white rabbit in a snowstorm.

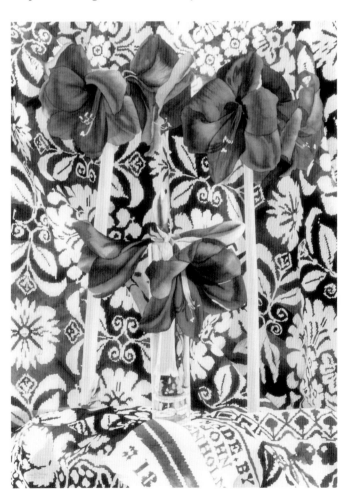

Middle-Value Subject

The amaryllis blossoms show up clearly in the black-and-white photo. Although the values range from white to black throughout the painting, the amaryllis blossoms clearly differ in value from the background.

In the black-and-white photo you see the values of the painting without regard to local color. The medium value of the amaryllis blossoms separates them from the busy black-and-white background pattern. Likewise, the broad, straight stems show clearly because they are also a different value than the background. This is a complex design and composition, yet it works.

PLAN YOUR PAINTING

Take time before painting to make sure you find the most pleasing arrangement of objects, values and colors. Remember, you have control over what you paint. If you are going to spend your creative energies, make sure you spend them well. Also, plan how you will save those important whites.

Dark Subject, Light Background

A black-and-white photo shows the values in the painting clearly, without colors confusing your eye. The dark, solid shapes of the tulips stand out against the lighter busy pattern of the quilt. The painting's value statement must be effective for the painting to be successful. Artists often use a different color to make a subject stand out from the background. More importantly, the subject must be a different value than the background as well! Not only do the red tulips show up clearly, but the vase shows up against the background because the edges are a different value.

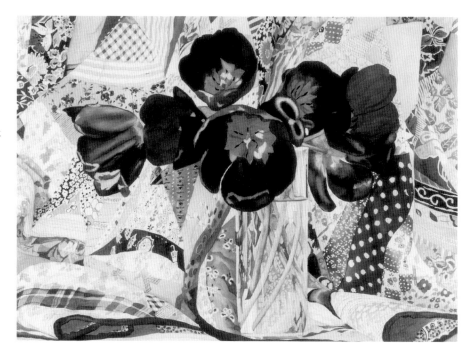

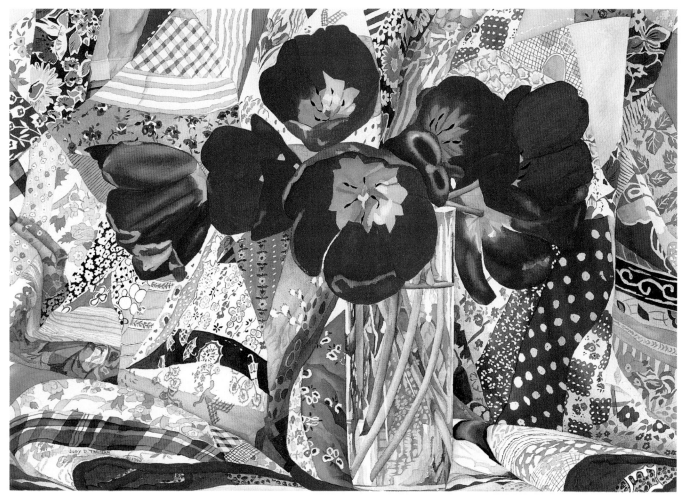

JUDY D. TREMAN
Ribbon Quilt With Tulips
Watercolor
20" × 28" (51cm × 71cm)
Private collection

Squint your eyes and look at the painting. The darker red tulip blossoms stand out strongly against the lighter quilt. This difference in values makes the painting dynamic. Color adds to the vibrancy, but the value of the subject must stand out from the value of the background.

Add details and colors freely within the structure of the carefully planned value statement. In this case, I included areas of red, yellow and green in the quilt to complement the rich red of the tulips and make your eyes dance between the foreground and the background.

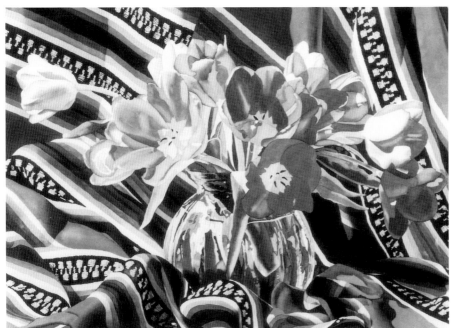

Light Subject, Dark Background

Observe how well the tulips show up in the black-and-white photo, although the local colors of the red tulips and the red in the blanket are the same. Use sunlight and shadows to make different values, since both tulips and blanket are red. I carefully position light values of sunlit tulips against dark values of shadowed blanket, or more importantly, place the subject against a different-valued background.

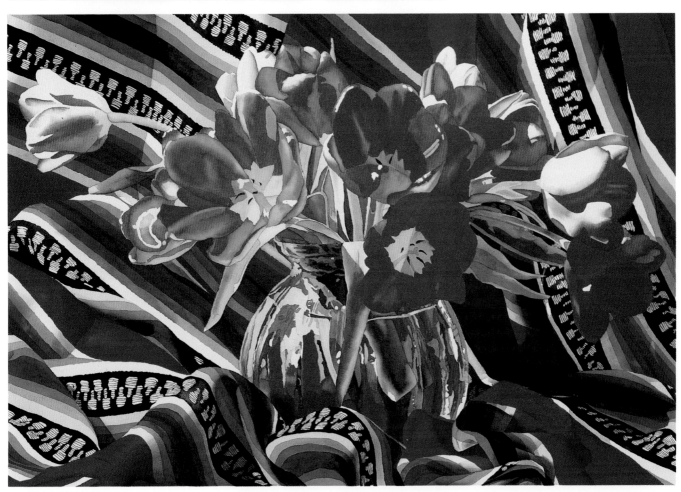

JUDY D. TREMAN
Jubilation
27½" × 39" (70cm × 99cm)
Watercolor
Private collection

How can you see red tulips against a red background? Carefully arrange each of the red tulip petals against different values and colors; otherwise, they blend together. Notice how the white highlights of the tulips make them stand out against the red background. Likewise, red petals appear against darker (or lighter) backgrounds. Examine each blossom and see how it shows up against the background.

Jubilation is a knockout in value alone, but when you add color, it is sensational. The red tulips play off the greens, blues, blacks and whites.

Lights and Darks for Vivid Color

Set off your brilliant colors to their best advantage by using predominantly light or dark values in your painting. Using mostly middle values does not give the structure required to enhance vivid colors.

The local colors you choose for your subject matter will help determine the values of the painting. You can make a very dark color light by adding a lot of water. Colors such as Permanent Alizarin Crimson, Winsor Violet, Winsor Blue or black can span a large range of values from light to dark. Other colors such as yellows have only light values.

Before you paint, decide if you want predominantly dark or light values in your painting. Think about which will most dramatically display the subject and/or feeling you wish to portray. A half-and-half split between dark and

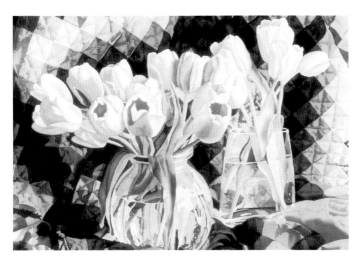

Predominantly Dark Values

Without the benefit or confusion of color, study the values of the painting in this black-and-white photo. The painting is predominantly dark values. Light values of the tulips and vases show up more sharply against the dark background, whereas a light background would not be as effective. The sunshine sparkles more for being placed against the shadows.

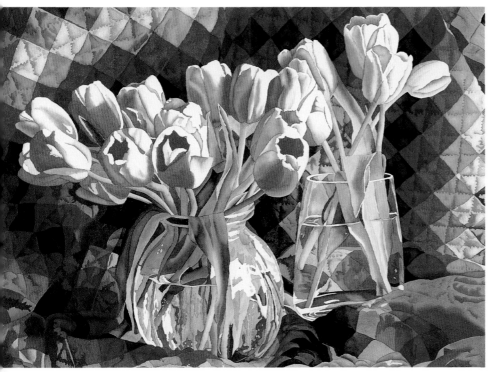

JUDY D. TREMAN
Sunshine and Shadows
Watercolor
28" × 39½" (71cm × 100cm)
Collection of the artist

The interweaving of sunshine and shadows gives the painting its name. The overall dark values in this painting dramatically contrast the light pink tulips. You best appreciate the brilliance of sunshine when it is contrasted against shadows. The pink tulips range in value from white through pale pink to very dark pink. Their colors echo the quilt pattern, in which each color has three increasingly darker shades as it goes from sunshine to shadows. Squint your eyes to see the tulips leap out from the quilt. Each light blossom stands out against a darker background. Each petal stands on its own against its neighbor.

light values is not usually as interesting as mostly dark or light.

Generally, a one-third to two-thirds proportion between dark and light is more pleasing and exciting.

The paintings on these two pages show different ways to paint the same pink tulips. Both paintings are strong and successful. *Sunshine and Shadows* (opposite) has predominantly dark values, giving a more dramatic impact to the highlights. The darker background emphasizes the pale, rounded shapes of both vases and tulips. On the other hand, light values are predominant in *Dresden Plate Quilt With Tulips* (below). The light-colored quilt accents the darker pink globular tulips. A dark value in the vase would split the painting in half between light and dark values and diagonally from lower left to upper right.

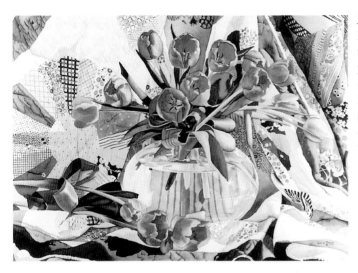

Predominantly Light Values

In the black-and-white photo we look only at the value structures, without the interplay of pinks and blues. Note the overall light values of the painting, but also note how critically important the dark shadows are in giving shape and form to the flowers, vase and quilt. Without these dark areas, the painting would be ordinary and wishy-washy.

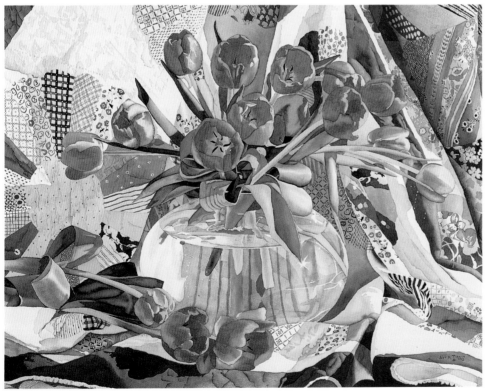

Squint your eyes and notice how this painting is predominantly light values with some darker accents. See how successfully the pink round tulips show against the light background. Placing the light, round vase against darker shadows emphasizes its shape. The darker blue quilt pieces keep your eye moving around the painting. While most of the painting is light to middle values, there are some very dark areas that give power to the painting.

JUDY D. TREMAN
Dresden Plate Quilt With Tulips
Watercolor
28" × 39" (71cm × 99cm)
Private collection

Use a Full Range of Values

Brilliant colors call for strong designs, and this means using a full range of values, from light to dark. Before you paint, think about how you can use a large range of values to energize your design. Be careful not to lose some of your power by choosing too narrow a range.

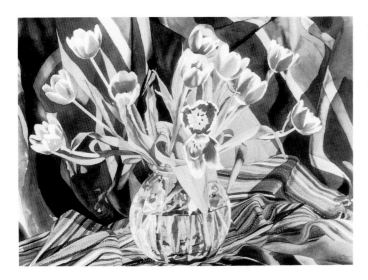

Full Range of Values

This painting has a very dramatic impact and a full range of values from white to black. This black-and-white photo helps us see the values without regard to local color. Notice the use of various values throughout the painting and how dramatically the tulips stand out against the lively background. Tulip petals show a variety of values from white to dark, and the striped fabrics range in value from white to black as well.

Strong shadows force their way through the different stripe colors, and dabs of light cavort around the painting. Values determine not only the shadows, but also the contours of the tulips, the folds of the fabric and the very shape of each object. The stripes are different colors and values as well.

JUDY D. TREMAN
Fantasia
Watercolor
29" × 40"
(74cm × 102cm)
Private collection.

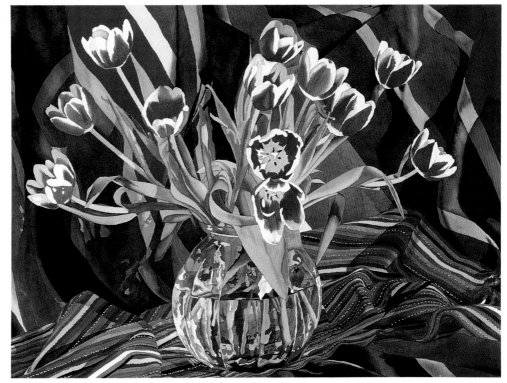

The bold, colorful stripes in the two fabrics could easily overpower *Fantasia*, but the extreme strength of the underlying framework of shadows makes the painting successful. Shadows stand out, even with the bold-striped fabric. The individual stripes include a full range of values as well as different colors. The interplay of all the different values and colors makes *Fantasia* a very lively, dynamic painting.

Squint your eyes. See how the white stripes of the tulips pop out, echoed by the white edges of the vase and the white stripe running through both fabircs. A full range of colors and values animates the painting.

Exaggerate Values for More Drama

When painting with brilliant color, take care to exaggerate lights and darks in the underlying shadows and highlights. Vivid washes of local color overwhelm delicately hued shadows. Make your colors more vibrant and your values darker or lighter than you think they should be.

Remember: One of the keys to beautiful watercolors is to let the white paper glow through the color! Even though you want to exaggerate your values, let the white paper show through the darkest colors to keep them vibrant.

In judging an art contest, a local group asked me to make comments to each artist about the paintings. I found the paintings generally needed a stronger value statement. The artists were either afraid to make strong values by using both very dark and very light, or the values did not come across with the strength the artists wanted. The paintings tended toward the mid-range of values.

It is safe to create middle-of-the-road paintings that do not require you to commit yourself to strong values. If you only have middle-of-the-road confidence, your paintings will reflect it. To create paintings that make strong statements, be bold in your values. There is a risk in making bold paintings, but once in a while you will create a masterpiece.

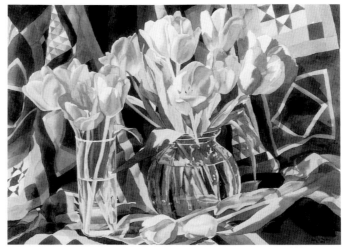

I exaggerated the values in the tulips, from white to very dark. Perhaps the juxtaposition of the light tulips against the darker patterns of the quilt makes it even more dynamic.

The shadows of the folds are strong enough to hold their own with the pattern of the quilt. Although the vases are the same colors as the background, delineate the vase shapes by exaggerating different values on the edges.

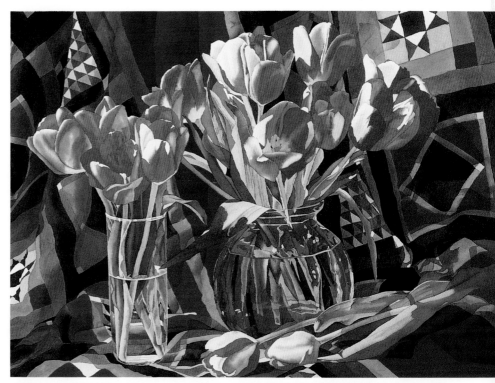

JUDY D. TREMAN
Simple Joys—
Amish Sampler
Watercolor
27½" × 39"
(70cm × 99cm)
Collection of the
artist

The interplay of lights and darks makes the rich colors come to life. Sunlight dancing over the simple tulips and sumptuous, dark colors of the Amish quilt portray a joyful mood. The highlights represent sparks of joy in austere surroundings.

Squint your eyes and see how the white splotches of sunlight pop out in dramatic contrast to the rich, dark shadows.

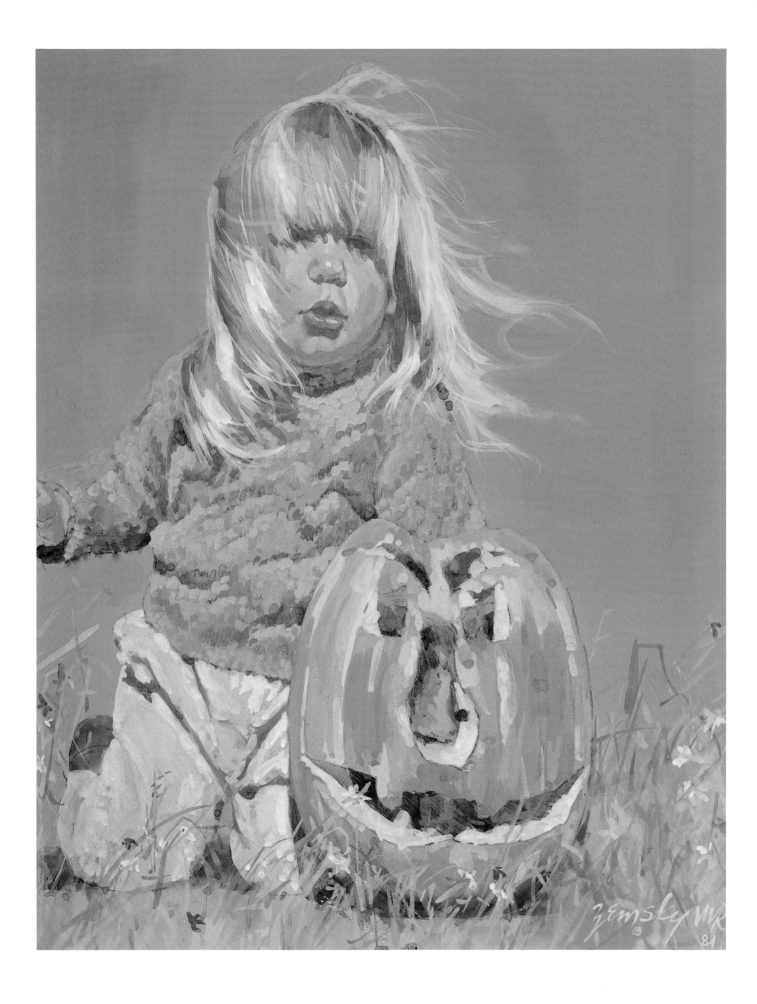

56

Color, the Magic Ingredient

Color pulls your whole painting together, expressing time of day, mood, personal feelings and unity. The way colors relate to each other gives your painting a certain feel. Keep in mind that you can do much more than just re-create the local color of a subject. There are special color considerations, for example, for achieving the lovely, living look of children in your paintings. There are special colors for certain places or moments. When setting up for a painting, try to choose props not only for subject matter, but for color too! Colors are fun, so work with them.

The artwork on page 56 was created by
Jessica Zemsky.

JESSICA ZEMSKY
Halloween Faces
Gouache
20" × 16" (51cm × 41cm)

VALUES IN COLOR

We know that every color has a value. Somewhere on the value scale is a degree of darkness that equals every color. I believe value is the most important aspect of color in particular and painting as a whole. Therefore, it's imperative while painting to be able to observe a color in your subject and translate its value into paint. Comparison is the key to solving any question you may have about the value of a color—that is, comparing the value relationships of your subject to the value relationships in your painting. Observation and practice are the two things that will help the most.

HUE AND INTENSITY

Hue and intensity provide the artist and viewer the pleasure of color and mood. Without hue and intensity, our paintings would be black and white and composed of values, but no color. And it's important to remember that I might see color differently than you or the next person. Our eyes and minds don't necessarily process color in exactly the same way. But if the values in a painting are correct, then colors are allowed to vary with the artist's discretion and still register as convincing and natural.

The artwork on pages 58-59 was created by Tom Browning.

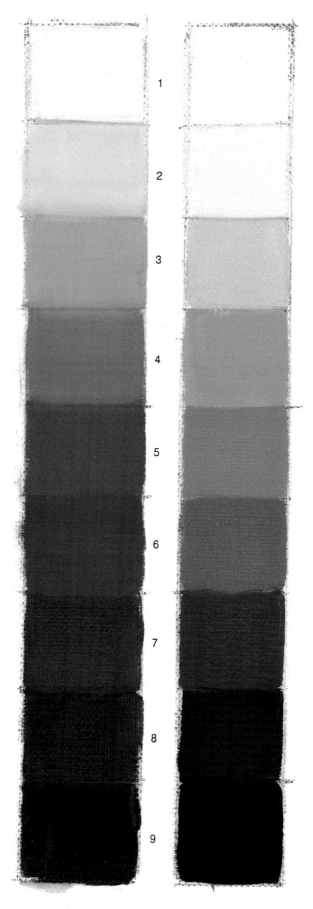

(Left) Every color and degree of color has a value that corresponds to a placement on the black-and-white value scale. Here the color Cadmium Vermilion (no. 5) progresses from its darkest value to its lightest tint.

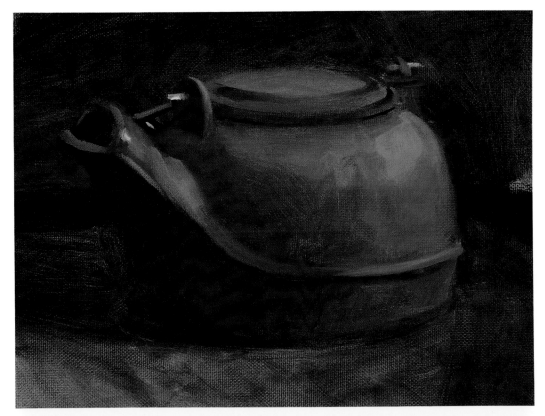

Here I've painted a black stove kettle using black and white paint to demonstrate how cold and lifeless such an object might be seen.

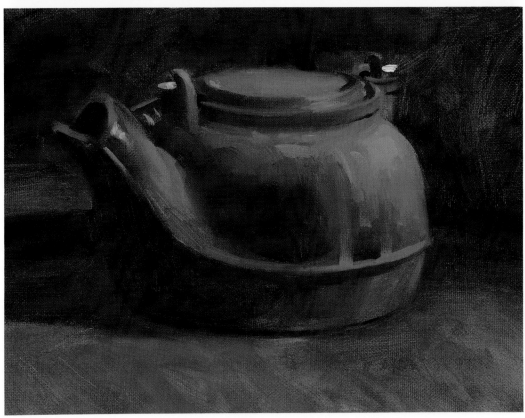

The same object painted in color reveals a lot more of its character, such as rust and age. I could carry it even further with observations of subtle color changes and capture even more of its beautiful qualities.

Color Notes

When painting nature it can be helpful to think in terms of "color notes." This can help you make color decisions faster—especially important when fading light shortens your painting time.

When observing nature, try to see everything first as shapes of color; proper values (lights and darks) are also very important in a painting. Nature displays itself in full spectrum. We know that color has three qualities: hue, value and chroma. Some artists use the term "color" or "color note" interchangeably to mean the sum of these qualities. You can analyze everything as a particular color note.

If you can learn to see color notes when painting outdoors, you do not have to worry about determining value, because that comes automatically. A color note has an inherent tonal value, which makes the process of seeing pure and accurate color easier. This advanced way of seeing and understanding the relationship between color and value is most helpful for the experienced painter.

THREE QUESTIONS TO ASK ABOUT A COLOR:

1. Where does your color note lie within the spectrum? What is its *hue*?
2. How dark or light is your color note? What is its *value*?
3. How intense or dull is your color note? What is its *chroma*?

The artwork on pages 60-65 was created by Kevin D. Macpherson.

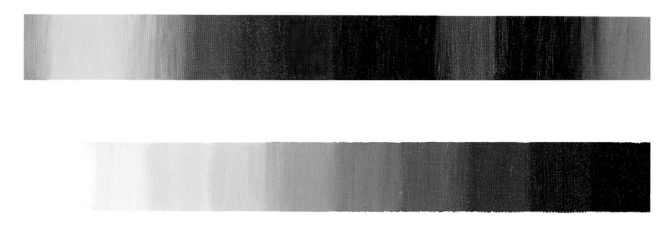

Hue, Value and Chroma

Hue is the name of the color: red, yellow, blue, purple, green or orange. *Value* is the relative degree of the grayness (darkness or lightness) from black to white. *Chroma* is the color's intensity or lack of intensity. Compare pure Cadmium Yellow Pale to a less intense Yellow Ochre.

Forget What You Know

Our preconceived thoughts limit our sensitivity to seeing. We need to forget what we know about color and learn to see all over again—learn to see as an artist.

Local color is the actual color of a subject, such as the red of an apple, the yellow of lemons or the blue of the sky. Yet as artists we must deal more with the color of light and atmospheric effects on objects. A red roof in the distance may appear purple, even though we know it's red. It is what we know that can get us in trouble.

The sky may appear green or rose because of pollution or dust in the air. A yellow lemon may be orange if it is bathed in a red light. That is why memorizing what colors to mix for an apple or sky limits you to mediocre painting. Each atmospheric and lighting situation presents itself differently; each should be painted differently.

FACTORS THAT AFFECT LOCAL COLOR:
1. Primary light source (for example, sunshine or artificial light)
2. Indirect light (reflected light bouncing off of other objects, or a secondary light source)
3. Atmosphere (light is filtered through atmosphere, such as particles of dust, water or smog)

Colors Influence Each Other
An object is influenced by the light and color of its surroundings. Examine each one of these photos carefully. A green pear is influenced by the oranges, reds or blues around it. The color of the shadow planes changes with the color of the tabletop and wall. The interaction of the pear, light and surrounding colors creates a natural harmony. If we cut one pear out and pasted it onto the other background, it would not seem to belong.

Painterly Planes

Planes are two-dimensional flat or level surfaces, like one surface of a cube (which has six obvious planes). While a ball has a spherical shape, it can be imagined as having planes. I carved the plane fruit shown below to illustrate the planes on various rounded objects.

Visualizing planes will help you see, simplify and understand color. Anytime there is a plane change, there may be a color change, and when there is a color change on an object, look for a plane change. In the beginning, it takes some practice to become aware of planes. To paint looser or more painterly, see and paint the big, obvious plane changes.

LESSON
With modeling clay, sculpt a curved object, such as a pear, using exaggerated flat planes, like the plane pear shown here. If you start with big planes, then make them smaller and smaller, you will eventually have the illusion of a rounded form.

Planes
The color transitions in the real pear are more gradual, more gentle, than those of the plane pear, which are more abrupt. But you can see the similarity. Recognizing the planes of an object and noticing at what angles they face light sources will help you see their colors.

Color is Relative

One color can become darker, brighter, grayer, warmer or cooler in relation to another color. You must relate and compare all the colors in your composition to each other. Compare similar colors in order to spot subtle differences between darks, lights, reds, blues, etc. Look for the warmest, coolest, brightest, dullest, darkest and lightest variation of each color.

One way I judge colors accurately is by holding up something dark (like the side piece of my eyeglasses) over a dark shadow area. A thin brush or stick will also work. This helps me see how dark, and what color dark, that shape is. Also, when painting outdoors, I often put a white tissue on a bush so that I have a pure white object to compare colors with.

Compare every color note you see with another, and ask yourself two questions: Is one color lighter or darker than the other? Is one color warmer or cooler than the other? Your eyes will become more sensitive to delicate color relationships as you practice comparing colors and increase your powers of observation.

THE MAGICAL COLOR ISOLATOR

The best way to see true color is with a handy device I call a *color isolator*. A simple version can be made out of a 1" × 3" (3cm × 8cm) piece of white cardboard with a hole punched through it.

Holding the color isolator about six inches from your eyes, close one eye and position the hole so that you can see the color of the subject area you are judging. This isolates a small piece of color so that you no longer see an object but only a specific color note.

When looking through the color isolator, do it fast. Trust your first quick impression. Even if the side of a face appears bright green, believe it. Flesh can be any color of the rainbow depending on its surroundings and light source. The color isolator will help you visualize without preconceptions.

How We Perceive Colors

Because the eye perceives a color in relationship to those around it, a color surrounded by dark colors is perceived as lighter than the same color surrounded by white. Experiment by choosing a color ands surrounding it with varying colored grounds. The color appears to change with its surroundings.

My Color Isolator

On one side, my color isolator has black, white and neutral gray sections. Each section has a hole so that I can compare how a color note looks surrounded by black, gray or white. The opposite side is all white so that I can compare up to three areas at once. Notice how obvious the color notes are with the background out of focus.

Mix-and-Match Colors

Pure tube colors are rarely found in nature, so you must learn to create mixtures. A few tubes of paint can yield endless variations.

Start a mixture with one of the most obvious color choices on your palette: yellow, red, blue, green or white. If a color is very light, start with white. You can also begin with a previously mixed puddle to get the next color.

Conduct a mental dialogue with yourself to determine color-mixing choices, asking questions as you work. Let's say the color note on your subject is closest to yellow, so begin with that.

What needs to be added next? Perhaps a small portion of red, which makes the mixture yellow-orange. But it is still too light and bright. Add a small amount of blue, which is orange's complement—the color directly opposite it on the color wheel. This makes the puddle darker, slightly cooler and less intense.

A color note on your subject may be warm blue, not too intense and of medium value. Is it lighter or darker than the mixture on your palette? Add some white if the subject appears lighter. Does your puddle of color need to be a little more yellow, red or blue? In other words, does the puddle need to be warmer (closer to yellow or red) or cooler (closer to blue)? If the subject appears less violet than your puddle, you may want to add violet's complement, which is yellow.

Once you feel confident that the color note on your subject and the color puddle on your palette match visually, put a small test patch in the appropriate area on the canvas. Hold a color isolator (see page 63) about six inches from your eyes, and quickly compare the test patch to the isolated spot on the subject. Adjust your mixture as necessary.

Mixing Color Charts

Mask off squares with tape on a canvas board. Fill the squares with the variety of mixtures. Use thick paint. Clean your brush and palette between each mixture. Reduce each color mixture with white five times, or spend an hour just mixing out of a puddle on your palette. Change the puddle from pure to gray, light to dark, red to blue. See the delicate and drastic changes you can make.

WHAT COLOR IS THAT?

Many students ask, "What colors did you mix to get that?" I usually don't know because there are hundreds of ways to combine colors.

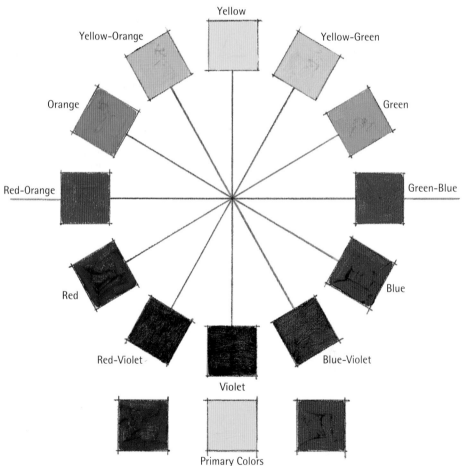

The Color Wheel

The primary, secondary and tertiary colors make up the color wheel. They all come from the three primary colors. The secondaries are made by combining two primaries. The tertiaries are made with a primary color and a secondary color.

Mix and Match

These three examples started with a color note to match. I then began my mental dialogue, and made obvious mixtures (right) for rough approximations of the desired colors. Were my initial mixtures too dark or too light? Were they too warm or too cool?

Top: The color note to be matched was a medium-value, medium-intensity purple. My initial mixture of Alizarin Crimson and Ultramarine Blue created a dark purple. I added white to lighten, which resulted in a too-intense purple. I added yellow to dull the note, but it was still too dark. I finally added more white for a match.

Middle: The color note to be matched was a dull green. My initial mixture of Cadmium Yellow Pale and Ultramarine Blue produced a too-dark, too-intense green. I added white to lighten, which resulted in the correct value, but it was still too intense. I added Alizarin Crimson, the complement of green, to gray it, which made the note too dark. I finally added white again for a match.

Bottom: The color note to be matched was a rich, dark orange. My initial mixture of Cadmium Yellow Pale and Alizarin Crimson created a rich red-orange that was too warm. I added Ultramarine Blue to cool and gray down the note, but then it was too cool. I added red to warm it up, but it was still too dark. I finally added white for a match.

COMPLEMENTARY PAIRS

Complementary pairs include yellow and violet, red and green, and blue and orange. Adding just a small amount of a complement will tone down a too-intense color without changing its value (lightness or darkness) too much.

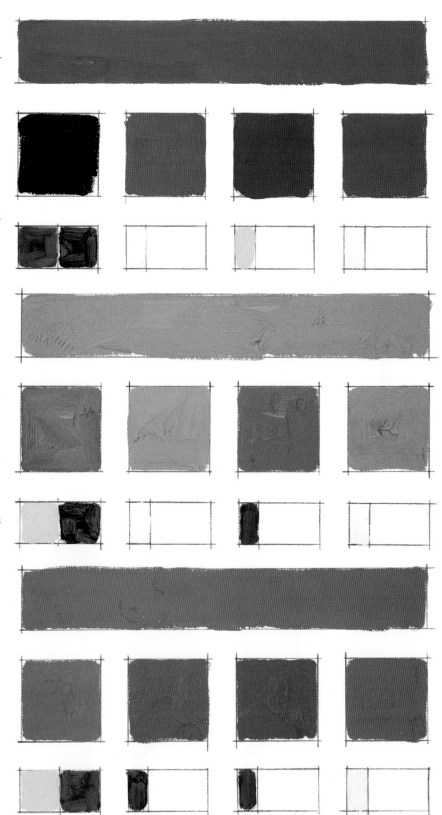

Other Methods of Mixing Colors

There are several ways to mix colors. Sometimes I prefer to mix colors on the palette using a knife or brush, while other times I like mixing pigment directly on the canvas. Another and perhaps more interesting approach is letting colors mix visually by placing them next to each other on the canvas.

VISUAL MIXING

Obviously, one color affects another. Directly mixing two colors will certainly result in a different color. But by simply being next to each other, colors can also have an obvious visual effect. The easiest way to observe this is by placing blue spots of color next to yellow spots of color. When you stand back, they tend to visually mix together, forming green. This technique was used by many of the French Impressionists. Another interesting exercise is to make several swatches of the same color, say a neutral gray-red. When the swatches become surrounded by grays of different hues, they appear to take on different hues and values. As you can see below, it appears that the center swatches are of different mixtures of paint, when in fact, they are all identical. This example of visual mixing might be intentional, or it might be involuntary, but you should always be aware of the effects you are creating.

The artwork on pages 66-69 was created by Tom Browning.

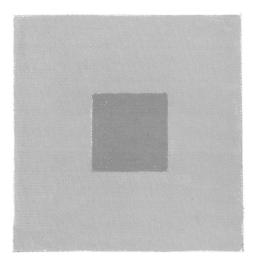
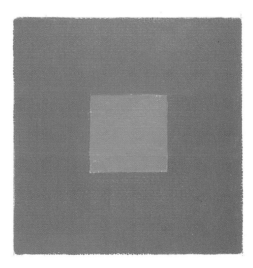

Notice how each center square is affected by the different colors around it. Although the center squares are exactly the same color and value, they appear to vary when subjected to different surroundings. The blue and green squares are the same values, but see how the square in the center of the green stands out against is complement, while the square within the blue seems more absorbed by its surrounding. The value of the center square also seems much darker when surrounded by a neutral light gray than it does when in the middle of a dark yellow.

MIXING ON CANVAS

Another method I use to liven up paint application is to mix colors and pigment directly on the canvas. This produces effects that can't be achieved any other way. It's similar to placing colors side by side to mix visually, but it gives the effect of a single stroke from a brush that's filled with more than one color. By not completely mixing two or more colors into a single color, an otherwise dull and lifeless area can appear lively and exciting.

Put one color down on your canvas, then drag another color over top of it. The result might be just what you're looking for: a mixture of colors that doesn't appear flat and dull. A palette knife can also be used very effectively to run colors together on the canvas.

A B A B

The swatches in the A columns show the effect of one color placed over another on the canvas. Both colors are evident, creating a visual mixture that is more pleasing than the single color made by mixing the two together, as shown in the B columns.

67

Darkening a Color for Shadows

When I want to make a color such as yellow a darker value, perhaps to indicate that it's in shadow, I start with its complementary color. Mixing black with yellow would result in a dirty green hue. But by mixing a bit of purple into yellow, a nice shade of yellow is produced. The intensity and the value are both lowered. The more purple added, the darker the yellow becomes. Try mixing complementary colors on a blank canvas and experiment with different ratios. It's amazing how many different values, hues and intensities you can achieve with two colors. A little white makes them even more neutral and varied.

Cadmium Yellow Light

Black

Cadmium Yellow Light

Cobalt Violet + White

Cadmium Orange

Cobalt Blue

Cadmium Red

Chrome Green + Black

Yellow Ochre

Blue + Red

Cobalt Blue

Alizarin Crimson

Using black to darken yellow creates an undesirable green. However, mixing yellow with its complement (purple) results in a nice dark yellow. The other swatches are examples of possible ways to darken colors.

Cadmium Yellow Light

Cobalt Violet + White

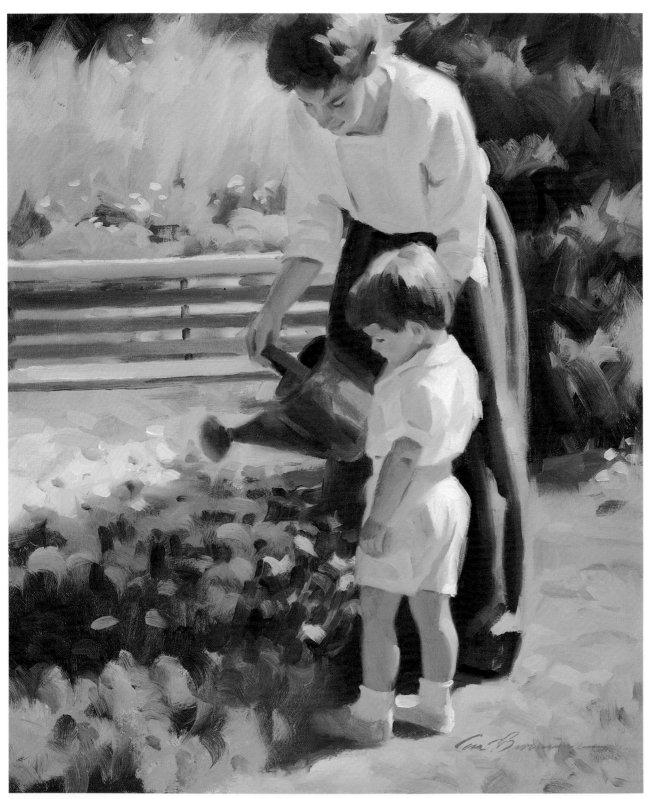

TOM BROWNING
Tending the Garden
Oil
14" × 11" (36cm × 28cm)

I wanted the yellow flowers in the foreground to emerge from the shadows into the sunlight. I used a purple mixed with ochres to darken the yellows in the shadow, then let this mixture blend into the greens. The flowers in the sunlight are pure yellow and white.

What About Earth Colors?

Earth colors are pigments like Yellow Ochre, Burnt Sienna, Burnt Umber and Raw Umber made from minerals such as iron, manganese, copper, etc. I do not use them because they are too convenient; many artists reach for them because they appear to be close enough to the color desired. Once you familiarize yourself with your limited palette, you will soon see that you can mix close to all the earth colors with it. It is better to mix browns accurately with a limited palette. A brown is a warm, dark orange. When looking at a brown, ask if it is more red, yellow, or blue; mix pigments accordingly.

The artwork on pages 70-71 was created by Kevin D. Macpherson.

BROWNS

Browns can be beautiful color notes, but many beginners use them too much. They can turn a painting to mud if used indiscriminately.

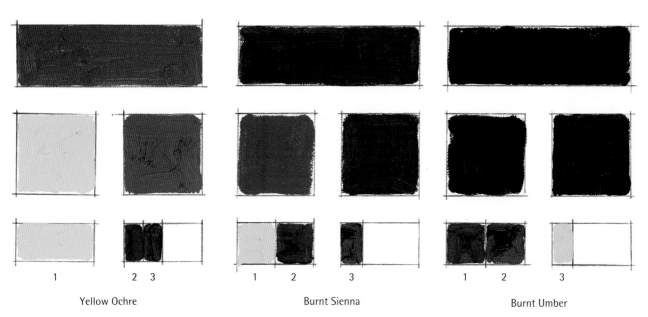

1	2	3
Yellow Ochre	Burnt Sienna	Burnt Umber

Mixing Earth Colors

The top color strips are the following earth colors directly from the tube: Yellow Ochre, Burnt Sienna and Burnt Umber. You can achieve very similar colors with the approximate proportions of the primaries indicated.

Mixing Sensitive Grays

If you can't exactly name a color, it is often what is called a neutral gray. Neutral grays are not just battleship gray, but include warm grays, cool grays, browns, mauves, etc. Gray is perhaps the most important unifying color the artist has, because it binds together the bright, intense color notes in a painting, and is also useful for adding variety and interest within major shapes.

There are infinite possibilities for producing beautiful, subtle grays when mixing colors. They include all the potential combinations of the three primaries with white in varying proportions. One way to mix a neutral gray is to start with a color and add an equal amount of its complement.

Determine what kind of gray you are looking at. Does it favor yellow, red or blue? Practice and become adept at producing subtle grays of the same value, with warm and cool variations.

BRUSH MIXING
Mixing with your brush takes less time than mixing with a palette knife and switching over to a brush.

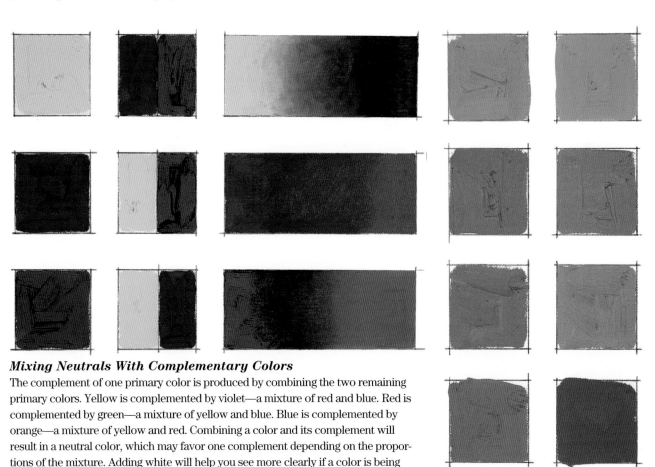

Mixing Neutrals With Complementary Colors
The complement of one primary color is produced by combining the two remaining primary colors. Yellow is complemented by violet—a mixture of red and blue. Red is complemented by green—a mixture of yellow and blue. Blue is complemented by orange—a mixture of yellow and red. Combining a color and its complement will result in a neutral color, which may favor one complement depending on the proportions of the mixture. Adding white will help you see more clearly if a color is being favored.

Color Temperature

A lot of students ask, "How can you tell what the temperature of a color is?" Naturally, colors don't have assigned degrees of temperature, so we're really only talking about warm and cool hues. That's not to say the subject should be dismissed as something that simple. On the contrary, color temperatures can control the impact of a painting and add convincing realism.

The theory of color temperature in painting that most everyone finds easy to accept is the fact that warm colors advance while cool colors recede. Simply put, the warm advancing colors are yellows, oranges and reds. Cool receding colors are greens, blues and violets. This advancing and receding relationship has to be kept in proper context, however, because a color in your painting that might register as warm and advancing will appear to be cool and receding when placed next to an even warmer advancing color.

Try covering a small piece of paper or canvas with a mixture of a neutral blue. Now in the center of this field place a spot of neutralized yellow. You can see how the warm color pops out at you while the cool field around it stays in the background. Try it with different color schemes and see which color mixtures best demonstrate this advancing and receding relationship. Then try adjusting the intensities. You'll see how a more intense color will attract the eye away from a more neutral hue.

The artwork on pages 72-73 was created by Tom Browning.

These simple swatches show how warm colors advance against a cool and more neutral background. On the right, the warm colors are intensified and they advance even more.

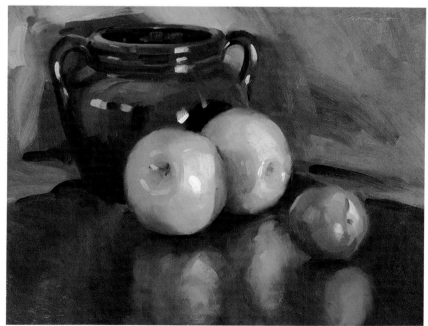

TOM BROWNING
Still Life with Fruit
Oil
12" × 16"
(30cm × 41cm)

The apples and nectarine, like the spots of color in the swatches, are both warm and intense and really stand out against the cooler and more neutral colors of the background.

This temperature relationship would also apply if you have an array of reds on your palette. Some reds will be warm and some will be cool. For example, Cadmium Red Medium has yellow in it, so it is a warm red. But Thalo Red Rose and Rose Madder have blue in them so they are cool reds. The same applies to yellows, blues and greens. Some are warmer than others. I find it valuable to determine the temperature of a color new to my palette before using it. This keeps me from trying to warm a mixture with a cool color and vice versa. So when setting up your palette, you might want to include a warm and cool version of each of the primaries.

I find it helpful to use a different brush when I warm paint mixtures than I use to cool paint mixtures. It's easier to cool off a warm color than it is to warm up a cool color, so I like to keep my palette and brushes as clean as possible to avoid these unwanted intrusions of cool into warm.

In the swatches at right, I've taken three different color mixtures—lavender, yellow and red—and shown what happens to their temperature when other colors of varying temperatures are introduced. Try laying out several swatches of the same cool color. Then mix different warm colors into them and see which colors have the best warming effect. Then lay out swatches of different cool colors and try warming them.

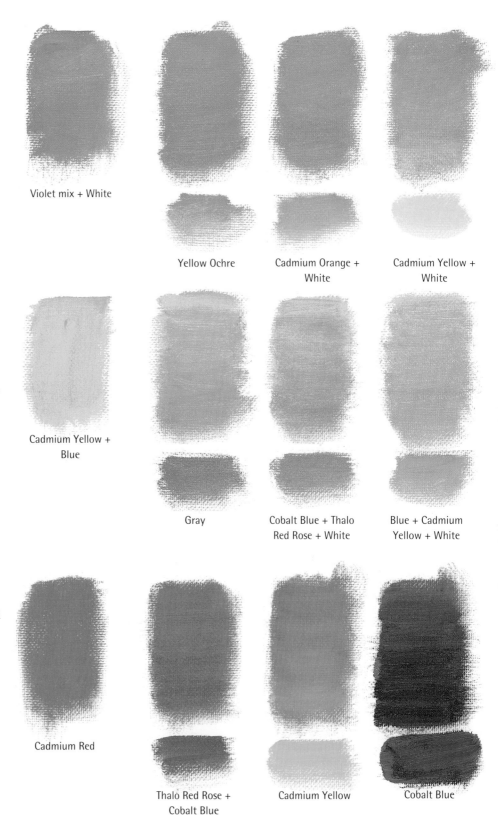

Violet mix + White

Yellow Ochre

Cadmium Orange + White

Cadmium Yellow + White

Cadmium Yellow + Blue

Gray

Cobalt Blue + Thalo Red Rose + White

Blue + Cadmium Yellow + White

Cadmium Red

Thalo Red Rose + Cobalt Blue

Cadmium Yellow

Cobalt Blue

Here I've laid down four swatches of lavender, four of yellow and four of red. I then ran warm colors up into the lavender to see how a cool color can be warmed up to different degrees. I then cooled off the yellow in the same manner. Red is usually considered a warm color, depending on the mix. Here you can see how it can be both cooled and warmed, and how a very cool and dark color like Cobalt Blue affects it.

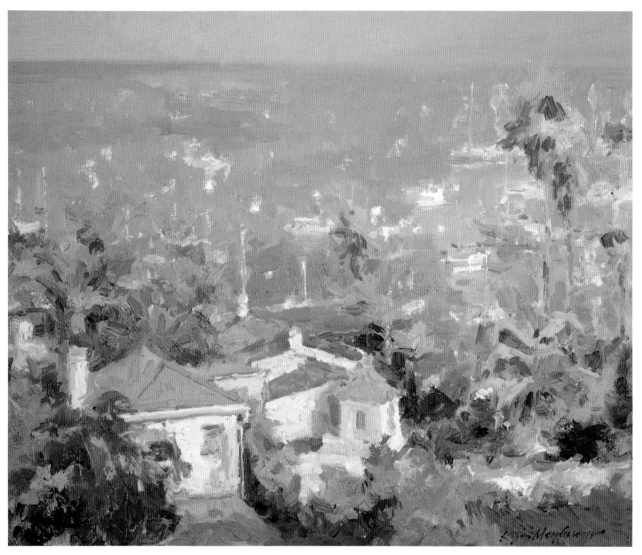

KEVIN D. MACPHERSON
Catalina Sunshine
Oil
16" × 20" (41cm × 51cm)

Warm and Cool Colors
The combination of warm and cool colors gives vitality and a feeling of light to this harbor scene. The color notes in the water, from left to right, are dark purple, blue and warm purple.

VALUE OR COLOR TEMPERATURE?

Many times we mistakenly adjust value when perceiving a color change in nature, though perhaps there is really only a slight temperature change. Squint your eyes to see if a value contrast actually exists before mixing and laying down your color.

The artwork on pages 74-75 was created by Kevin D. Macpherson.

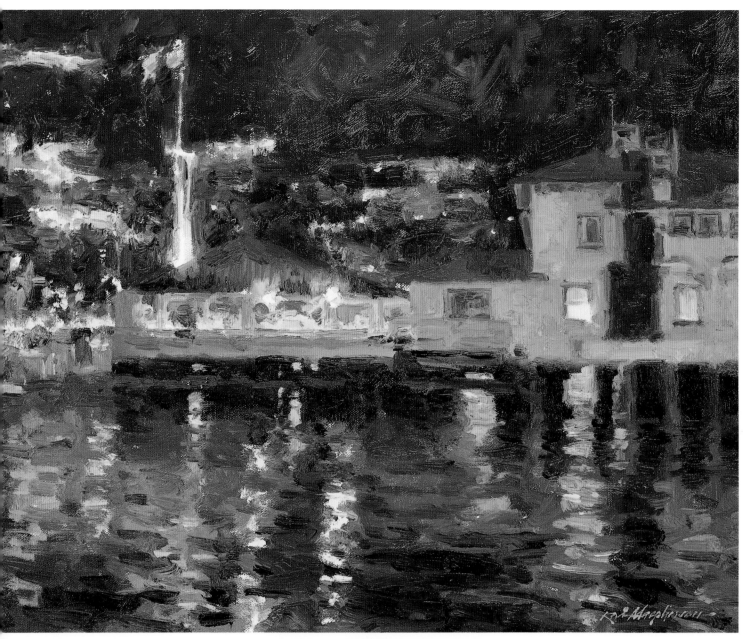

KEVIN D. MACPHERSON
Yacht Club—Night Scene
Oil
16" × 20" (41cm × 51cm)

Know Your Palette

You must ask yourself the same question when painting night scenes as you do when painting day scenes. Everything looks black at first, but once your eyes become acclimated to the darkness, you will see that there is a darkest area and that the other areas appear more colorful. Ask yourself, "What is the lightest light?" It is very important to know your palette when doing nocturnes. Set your colors out the same way every time.

FIRST COLOR NOTE

The first color note you put down must be

accurate, because all subsequent colors are

related to it.

Making Color Decisions

Having once —with sensitivity and intelligence— identified the color of a shape and placed it on the paper, a series of decisions is set in motion. You will want to place a color next to the first that will enhance both. Keep in mind that contrasts are complementary. As dark values make an adjacent light appear lighter, so also a warm complements a cool, a pure complements a neutral, and any hue complements its opposite. Your choices are limited to value, intensity, temperature or hue changes. Here, I talk about each choice separately.

LIGHT NEXT TO DARK

An arrangement of great shapes is essential to great painting. Once you have designed these great shapes and drawn them on the page, the next requirement is that you make them visible. I know this sounds obvious, but believe me, it's not. I have seen hundreds of paintings in which contrast of values, colors and textures have been reduced to an indistinguishable mush. It is not necessary to speak loudly, but it is essential to speak clearly.

One approach to making the shapes and patterns of your paintings visibly clear is to separate them by value contrast. When you do so, color takes a secondary role. You need only decide what value to make a shape. Forget the local color and establish the value contrasts that will make the shapes and composition clear. It isn't necessary to use color to paint; we compose with graphite all the time.

Value painters paint and observe with their eyes squinted. They can generally be recognized by the presence of crow's feet extending back to their ears. I have overheard my good friend Don Stone instruct his classes to paint with "half-closed eyes and a wide-open mind." The impact of a value painter's work is in the contrast of values and textures. The best of the value painters do not pretend to be colorists. They avoid strong color that compromises the effect of value contrast. This makes sense, for no amount of color can compete visually the effects of strong value contrast.

A declaration of intent is important to your artistic development. One of the things I admire about Alex Powers is his dedication to value and texture. He has no pretense or concern with color. Make your own declaration. It will make you a better painter and a happier person, improve your marriage and put a bounce in your walk. You'll hear better, see more clearly, and be more enjoyable to be around.

The artwork on pages 76-81 was created by Skip Lawrence.

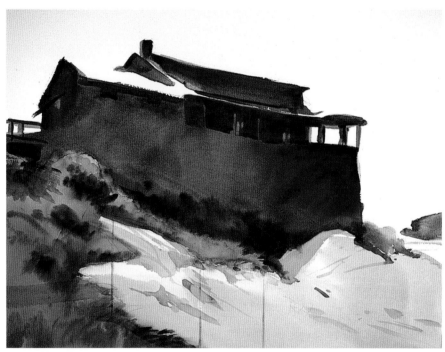

SKIP LAWRENCE
Red House
Watercolor
20" × 26"
(51cm × 66cm)

The so-called Red House of Monhegan Island has been painted thousands of times because of its interesting and varied shape. A shape like this can be interpreted in value or color. Because my infatuation was for the light, I did this painting with strong contrast of value—dark against light.

WARM NEXT TO COOL

Alternating the temperature of shapes from warm to cool is a simple and effective way of making the shapes of your painting read clearly. With this approach, as with any color-based approach, it is not necessary to rely on value contrast. It is not even advisable to allow value contrast to override the subtle beauty of temperature changes. Alternating temperatures is not limited to juxtaposing shapes, but can be used to enhance shapes by layering cool colors over warm and vice versa (more on this approach to follow).

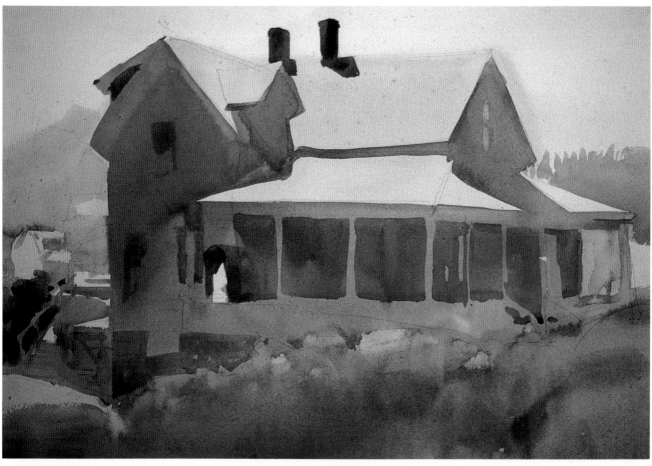

SKIP LAWRENCE
High Noon
Watercolor
15½" × 22" (39cm × 56cm)

My total reason for doing this painting was the warm light and the cool shadows. If you look closely, you will see that any surface that received light was painted in warm colors. Those surfaces in shade were painted exclusively with cool colors.

PURE NEXT TO NEUTRAL

It has been my experience that all students generally have to grow along the same route. First is the understanding of seeing and painting in values, followed by temperature and hue, while awareness of changing intensity relationships comes last. The next time you go out to paint, look at the subject and instead of identifying shapes by value or color, seek out the most intense color.

Distinguish the range of intensities from the most pure to absolute neutral, then make a painting that emphasizes an intensity scale. You will be dazzled by the results.

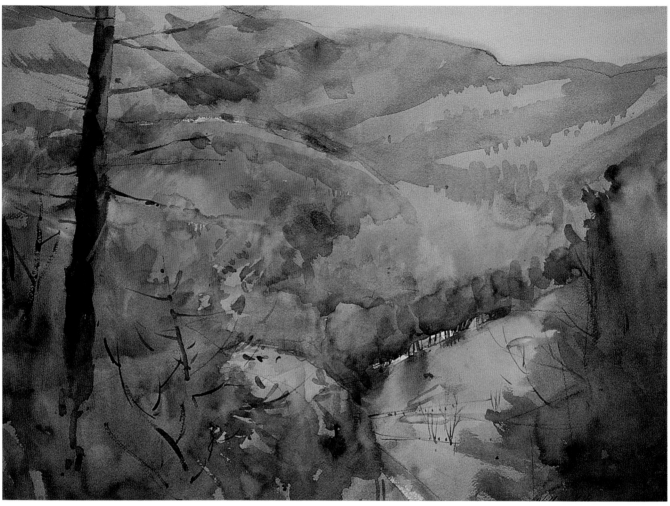

SKIP LAWRENCE
Off Springmaid Mountain
Watercolor
20" × 26" (51cm × 66cm)
Collection of Gerald McCue

I find mountain landscapes difficult because they demand aerial perspective solutions. In this case, I solved the problem by reducing value and thinking only in intensity relationships.

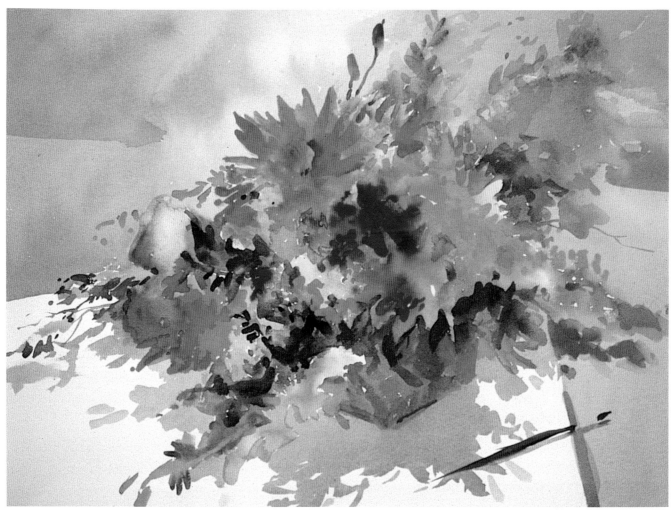

SKIP LAWRENCE
Picnic Flowers
Watercolor
20" × 26" (51cm × 66cm)

Flowers are a natural subject for looking at color intensity harmonies—pure flowers against neutral intensities.

SKIP LAWRENCE
Pulling Together
Watercolor
22" × 30" (56cm × 76cm)

I could not resist the title for the piece, since it portrays newlyweds living on Monhegan. The orange slickers offered a perfect chance to play pure hues with near-neutral intensities. After establishing the orange, the game was to keep all other hues varied in value and intensity.

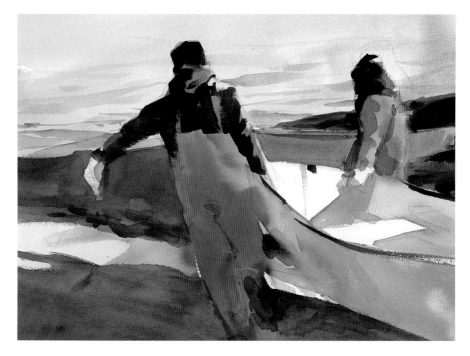

HUE NEXT TO HUE

I'm crazy to include this segment on color relationships, for while placing one color next to another is essential to making paintings, it is so infinite in possibilities that generalizations are difficult. Imagine how many thousands of colors exist of the primary, secondary and intermediate varieties alone. To paint with pure hues (red, yellow, blue, green, orange and purple) without the modifying qualities of value, temperature and intensity, is to paint like a child.

If you believe, as I do, that depth of knowledge is proportionate to breath of experience, then it is important to know what it feels like to paint with hues only. For your initial painting I suggest you divide your palette into three categories: light values (yellows, yellow-greens and oranges), middle values (reds) and darks (blues, greens and purples).

Working from a value pattern that clearly defines the shapes of light, middle and dark values, paint the light value shapes with the pure pigments from column 1, middle value shapes from column 2 and dark value shapes from column 3. The resulting painting may be unlike anything you have done before. Before you decide never to try this again, look at the paintings of the German Expressionists, the Fauvés and Vincent Van Gogh. If you like the results, you may have just taken a major step in your art development from "watercolorist" to "painter."

The point of all this is to encourage you to use the watercolor pigments,

when appropriate, in their full intensity. Diluting the pigments with water is not mandatory. The effect of water on pigments is a reduction in intensity and lightness in value. How often has someone compared your painting to your palette and said, "Your palettes is beautiful!" The reason the palette is more exciting is that the pigments have not yet been mixed, glazed, blotted and otherwise tortured to the point of nondescript identity. The pigments, as we buy them, are as rich and beautiful as they can be. Not to use this portion of the spectrum is to limit your vocabulary. It is possible to paint with a limited palette, but success will be in spite of the limitations and not because of them.

Here are some practical applications of hue next to hue:

- When making darks, use pure dark pigments instead of mixtures of brown "gravy."
- Use gradations of colors from the color wheel to create contrast and harmony within a shape. For example, when painting green shapes, such as foliage, paint from blue to blue-green to green to yellow-green to yellow. With this gradation you will have the contrast of blue to yellow and the visual excitement of the sequential change of numerous colors.
- Colors close in value can be altered randomly and will be harmonious.

MY PRESENT PALETTE IS DIVIDED AS FOLLOWS:

Light pigments
- Winsor Yellow
- Thalo Yellow-Green
- New Gamboge
- Raw Sienna
- Yellow Ochre

Middle pigments
- Turquoise
- Viridian
- Permanent Red
- Indian Red
- Cobalt Blue

Dark pigments
- Thio Violet
- Ultramarine Blue
- Winsor Violet
- Winsor Blue
- Winsor Green

SKIP LAWRENCE
Fall Foliage
Watercolor
5" × 7" (13cm × 18cm)

This color sketch is a prime example of shapes that read clearly because of hue next to hue. It was done in response to an October in New York state. The subject matter often gets in the way of the most obvious expression of our reactions to a place. Not many go to Vermont to see maple trees, but thousands go annually to marvel at the colors.

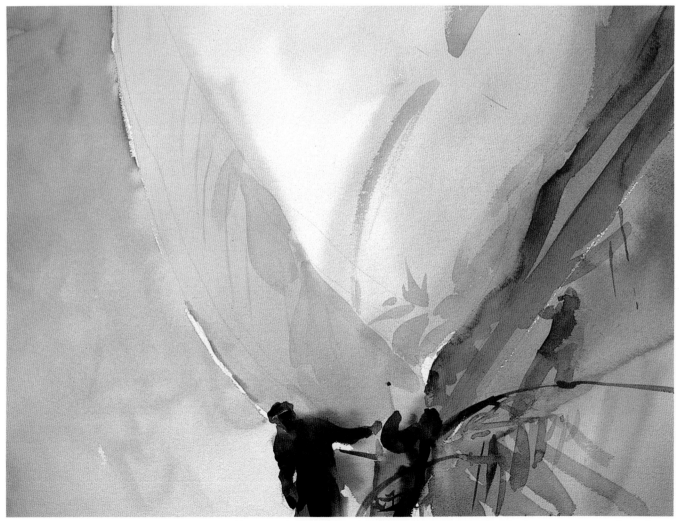

SKIP LAWRENCE
Skipjack Jib
Watercolor
22" × 30" (56cm × 76cm)

Trying to show the billowing quality of a sail was achieved, after many attempts, by reducing the value contrasts and making nothing but color changes. If you want a challenge filled with fun and frustration, try painting with only hue changes.

WHITE AREAS

White reflects color and light in such gorgeous ways. It has a wonderful way of picking up the colors around it while still keeping its integrity as white.

Try using a lot of white if using an opaque medium. It is helpful for bringing up the value of color. You don't want your color to be chalky, but if white is used discreetly, it can achieve lovely, opalescent tints.

The artwork on pages 82-83 was created by Jessica Zemsky.

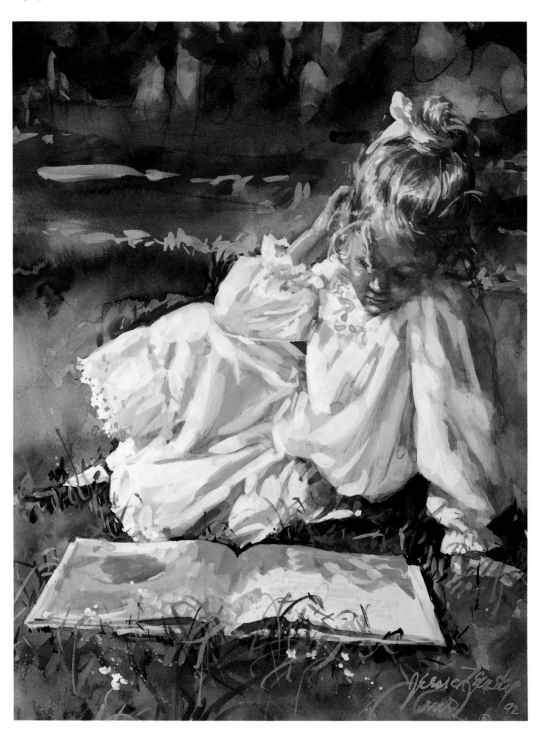

JESSICA ZEMSKY
Story Time
Gouache
20" × 16" (51cm × 41cm)
Collection of the artist

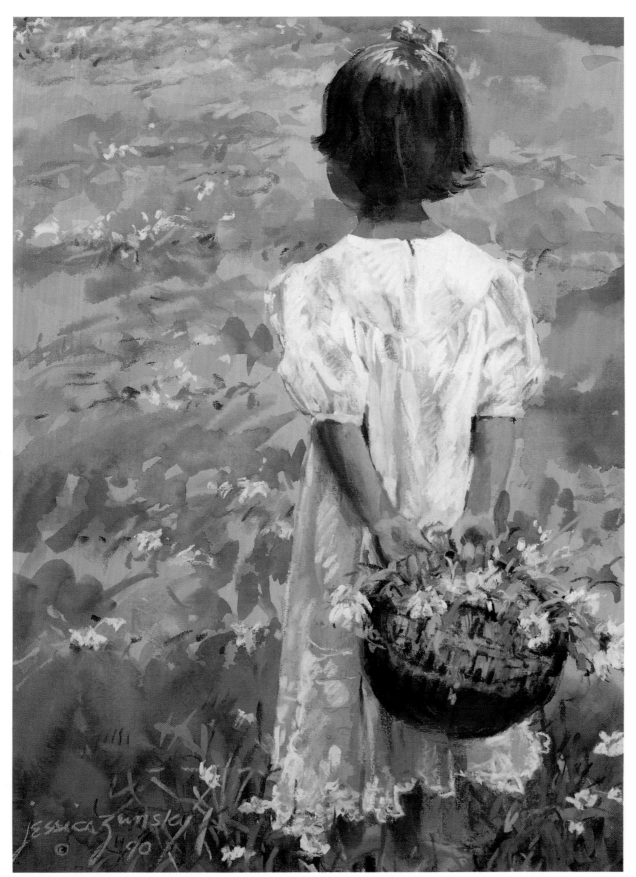

JESSICA ZEMSKY
End of Summer
Gouache
20" × 16" (51cm × 41cm)

Painting With "Broken Color"

A large part of what adds light and life to my paintings is what I call "broken color"—many, many fragments of bright pigment, sparkling and contrasting with the white of the paper. The eye dances over these bits of color, enjoying harmonies, contrasts and edges; seeing detail, perhaps where none truly exists; and taking pleasure in the feeling of light and movement. When your eye sees a color, it unconsciously seeks out other instances of that same color.

Because broken color attracts and delights the eye, it works best in and around the point of interest. Often it helps create the point of interest.

You'll find passages of broken color in just about every one of my paintings. Take a look at *S.F. Orient* on the right. This view of San Francisco's Chinatown is a riot of broken color, with rhythmic patterns inviting the viewer to explore, creating light, sparkle and interest.

To experience firsthand how you can use broken color to bring the point of interest to life, grab your brush and we'll develop a Portugese street scene in the next demonstration.

The artwork on pages 84-91 was created by Marilyn Simandle and Lewis Barret Lehrman.

MARILYN SIMANDLE
S.F. Orient
Watercolor
36" × 24" (91cm × 61cm)
Winner of the American Watercolor Society 1994 High Minds Medal

Repeated Color Patterns
The rhythmic lines, shapes and patterns of cityscapes create exciting eye movement. The composition of *S.F. Orient* is full of pattern and broken color. Even lettering, readable or not, creates pattern.

SIMPLFY!

Street scenes can easily become too complex. Try squinting at your subject to blur out detail so you see only the large shapes. Then paint the shapes you see, breaking them up afterwards for color and interest.

Creating Sunlight With Broken Color

MARILYN SIMANDLE

DETAILS, DETAILS

While developing a composition, you'll often spot some detail you want to include. If it doesn't belong in a simple value study, just sketch it off to one side for later reference.

PROFUSION OF DETAIL

A narrow street, a café with umbrella-shaded tables, bits of foliage, signs and awnings—a profusion of detail. The key is to pick and choose elements from these two photos to come up with a scene that's more effective than either appear individually.

1 DEVELOP A COMPOSITION WITH THUMBNAILS AND VALUE SKETCHES
Explore composition in a series of thumbnails. Should it be horizontal or vertical? How can dark tree masses be used to frame the light? How will the shop signs help create broken color?

My value sketch is simplified to just three values: light, middle and dark. Notice how connecting all the light, all the middle and all the dark values unifies the composition.

Diagonal shadow edges help
define the light source.

This will be the center
of interest.

This will be the
shadowed side of
the painting.

This will be the
highlighted side.

2 TRANSFER THE CONCEPT TO PAPER
Keep developing your design as you
sketch your composition on watercolor
paper. If something isn't working, change it!

Begin your wash at the top.

Warm it with Cadmium Orange for reflected light under the eaves.

Scratch lines into the wet wash with palette knife tip.

Cool and lighten for distance.

Keep shadow shapes connected.

Warm the wash to bring it forward.

Move the gray around your painting.

3 ESTABLISH LIGHT AND MOOD WITH FIRST WASHES

For important shadow shapes, mix an interesting gray, maybe Burnt Sienna and Antwerp Blue, and vary the mix each time you recharge your brush. Connect the shapes as you go, but be sure to leave sparkles of white showing through.

SAVE YOUR WHITES

If you're not yet comfortable with negative-space painting, try this: Paint in the positive shape itself, utilizing a very light wash compatible with the final color. If the negative area has to end up white, paint it with the lightest possible wash. Only you will know it's there. When it's dry, paint around it. I've done that here with very light Cobalt Blue laid into blossom areas of the foreground planter. Those areas will become pale violet later. You'll soon get the hang of negative painting, and you can skip this in-between step.

Start building up varied foliage greens: Cobalt Blue with Cadmium Orange, Antwerp Blue with Raw Sienna. Add a touch of Permanent Rose to gray it.

Scrape out wet color.

Keep elements dissimilar in shape and size.

Shadow awnings with a mixture of Cadmium Scarlet, Burnt Sienna and Cadmium Orange.

Begin building color into the point of interest.

Add light Cobalt Blue in blossom areas of planter.

4 DEVELOP BALANCED MASSES
Use a sunny mix of Cadmium Orange and Raw Sienna for the awnings.

Burnt Sienna and Permanent Rose for roof shapes, broken by "wire" line.

Use Cobalt Blue to glaze in shadow lines and values.

Colorful stripes imply a T-shirt.

Dark shadow balances large shadow mass at right.

Permanent Rose glazed over the light blue.

Darken this wash to emphasize a strong vertical.

5 BUILD UP COLOR, BREAK UP SHAPES

Glazing is a good way to break up both large shadow shapes and highlight areas. Now you can begin building broken color in the point of interest.

The line of umbrella fringes creates horizontal eye movement.

Dark values frame the point of interest.

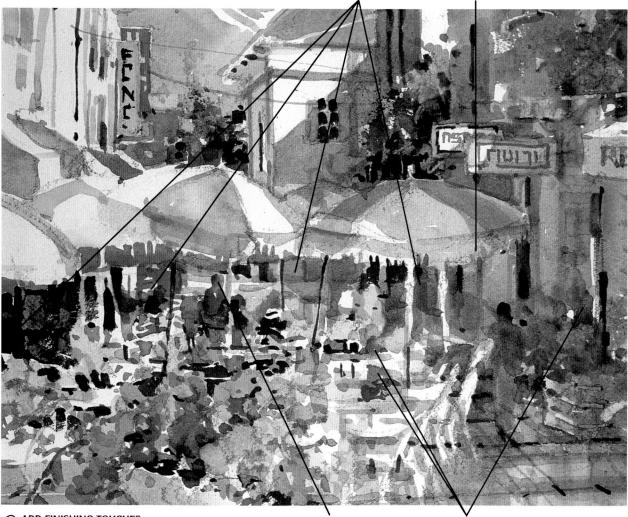

6 ADD FINISHING TOUCHES

Build color and value in and around the center of interest. This is where detail, if any, belongs, but note how little actual detail there really is here! Broken color suggests people, tables, even the happy chatter of voices and clinking of glassware. Now's the time to have some fun with line work. Use your rigger brush for pavement lines, suspended wires, building edges and such, but don't overdo!

Simple shapes suggest figures without defining them.

Spots of pure Permanent Rose are moved around the painting.

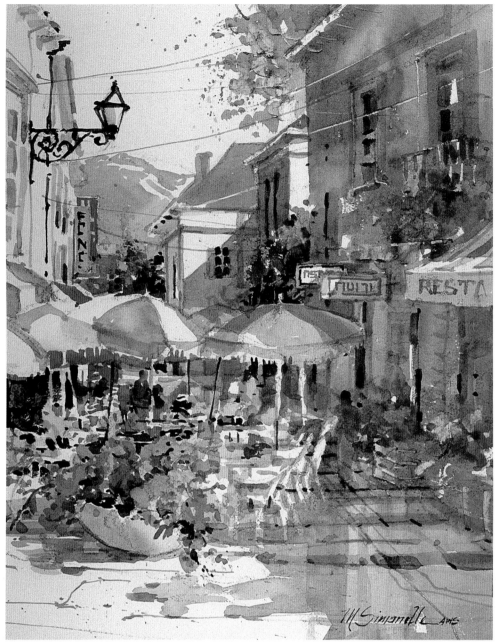

MARILYN SIMANDLE
Lagos Street Scene
Watercolor
18" × 14"
(46cm × 36cm)

Capturing Light

See how those umbrellas seem to sparkle in the sunlight? To capture light in watercolor, you have to contrast it against adjacent darks. It looks like there's a lot going on in the point of interest, but it's really very simple: broken color, light, shadow and shape.

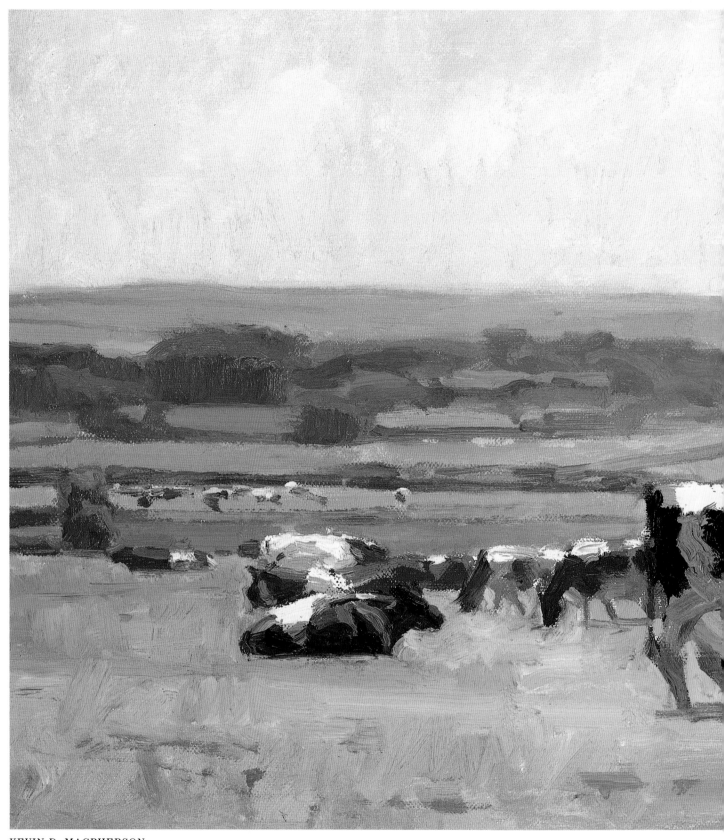

KEVIN D. MACPHERSON
Serene Pastures
Oil
12" × 16" (30cm × 41cm)

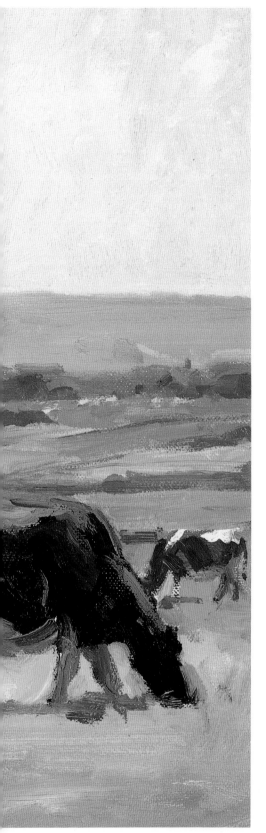

Create Moods and Special Effects

Once you have the ability to see color and analyze everything in terms of it, you have total power to paint anything you desire. You must train your eye to see and simplify. Painting, especially outdoors, is not an easy task. You must use everything at your disposal to make it go smoothly.

The artwork on pages 92-93 was created by Kevin D. Macpherson.

Painting Shadows

Some artists start by painting shadows first, building forms based on the light-and-dark pattern of an established direction of light. Then, they glaze color over these shadow patterns. Other artists complete the painting and add the shadows last, so that they will be less likely to confuse the direction of light while painting. Still others develop the shadows as they go along, keeping a fixed source of light in mind throughout. Try all three methods and pick the one that suits you.

The artwork on pages 94-99 was created by Nita Leland.

Exercise
PAINTING SHADOWS FIRST

If you've never done a "shadows first" picture, try it now. Sketch your subject and create all the shadows with a low-intensity blue or violet or a chromatic gray. Pay careful attention to the upturns of the shadow shapes, connecting them to achieve a cohesive pattern. When the shadows are done, glaze over them with the colors of the objects, influenced by the dominant light to unify the picture. You can add additional color and value contrast anywhere it's needed, when the glazes are dry.

Shadows Unify

The shadow pattern above moves across the sketch, unifying different areas in the picture. When you add color, the shadows fall into place without calling undue attention to themselves.

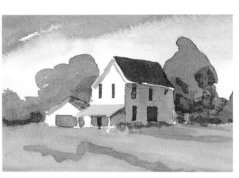

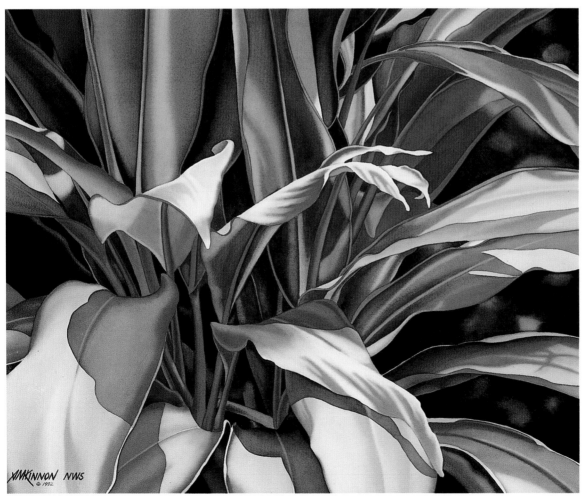

SUSAN MCKINNON, NWS
Sun Ti
Watercolor on paper
21½" × 29"
(55cm × 74cm)
Private collection

Strong Light and Color

Vibrant combinations of warm and cool colors in the shadows pick up the complementary hues that dominate this painting. Transparent glazes lie clearly on the smooth leaf surfaces, and the intricate shadow patterns are a strong counterpoint to the light.

Dominant Light

Different artists rarely represent light in the same way. To paint light, first you must carefully observe the light in nature and then determine what colors are needed to achieve that effect or change it, if you want a different effect.

Careful observers can see continuous variations in light, but this takes practice. Natural light changes constantly and is primarily influenced by the time of day, the geographic region, the season and weather conditions. Be aware of changes in indoor artificial light as well as outdoor natural light.

Use your color journal to record your observations of light effects, then experiment with various ways of using color to represent them.

Time of Day, Weather, Season...

These mingled colors show just a few of the myriad effects of dominant light. Try these combinations, then make up some of your own to express your favorite time of day, weather condition or season in color.

MORNING
Pearly Soft
Rose Madder Genuine, Cadmium Scarlet, Aureolin, Cobalt Blue

MIDDAY
Strong Contrast
Permanent Rose, New Gamboge, French Ultramarine

LATE AFTERNOON
Golden Gray
Thioindigo Violet, New Gamboge, Cobalt Blue

SUNSET
Brilliant Pure Color
Alizarin Crimson, Cadmium Scarlet, New Gamboge, Phthalo Blue

MOONLIGHT
Soft Monochromatic
Cadmium Red, Phthalo Blue

FOG
Soft Monochromatic
Burnt Sienna, Raw Sienna, French Ultramarine, Davy's Gray

WAYS OF ACHIEVING LIGHT EFFECTS

Use these checkpoints to evaluate how the effect of light is achieved in the artwork that follows:
- Color dominance
- Contrast
- Light source
- Type of light (natural or artificial)
- Color scheme
- Glazing
- Gradation
- Tonal support
- Shadows
- Reflected color

Exercise
SUGGESTING DOMINANT LIGHT

On the following pages you'll find descriptions of several qualities of dominant light and artworks that illustrate different aspects of light, along with brief explanations of how color contributes to create that particular effect. Study these examples, then make sketches of your own, using color to capture the sensation described. Plan your color effect with color schemes to get the most consistent effect of dominant light. Record the colors you use for your effects for future reference.

Time of Day

Every time of day has its own special light. Early morning light is luminous and clear with high-key color and gentle contrasts. Tints of scarlet, blue-green and violet express the awakening day. At midday a harsher light reveals intense contrasts of color and value, bleaching out highlights. Late afternoon light has a softer golden glow, with distant objects veiled with mist leaning toward chromatic and neutral tones. Twilight and early evening light are luminous, tending toward blue and violet, with the sunset a deep rich crimson. Atmospheric buildup throughout the day causes red rays to scatter widely and fill the sky and landscape with color.

Exercise
RECORDING THE TIME OF DAY
Study the paintings on this page to analyze how artists have depicted a particular time of day. Make your own sketches of color effects showing the changing light of day.

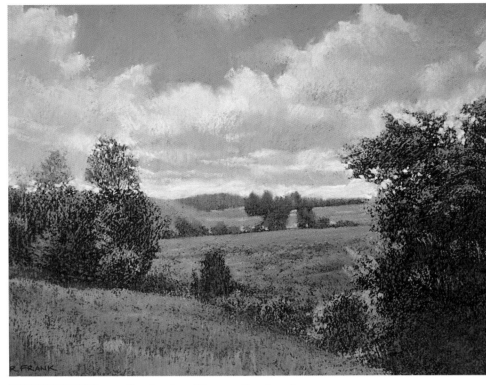

ROBERT FRANK
Breezy Day
Pastel on paper
19" × 25"
(48cm × 64cm)
Collection of the artist

Capturing Strong Contrasts
The yellow light of the sun bathes the green landscape, and blue sky reflects in the shadows. Frank knows every trick of painting light, so you may be sure his use of realistic local color is an intentional means of capturing the strong contrasts of light on a sunny day.

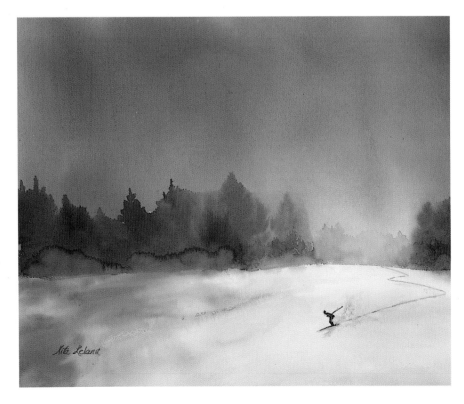

NITA LELAND
Free Spirit
Watercolor on paper
14" × 20" (36cm × 51cm)
Collection of Wes and Laura Leland

Expressing Time of Day
An intense palette of Winsor Red, Winsor Yellow and Winsor Blue makes rich, low-intensity washes surrounding the glow of the last light of day as it reflects off snow. Does light ever look like this? Probably not. But do the colors express the time of day effectively? I think so. You can take all kinds of liberties with color if you make your point.

Geographical Location

The color of sunlight in the northern hemisphere is warmer in summer than in winter. The light of the Southwest differs from that of New England. What's the dominant light like in your region? If you're not sure about this, you can easily find out by visiting a local art exhibit. Artists tend to paint the light they are most familiar with, often without even being aware of the influence in their work. Study the light in other areas to see how different it is from the light you're familiar with.

Exercise

PAINTING REGIONAL LIGHT

Study the light of four different regions you've visited or would like to visit. Mingle colors to find combinations that suggest the light of each region and make sketches using these colors.

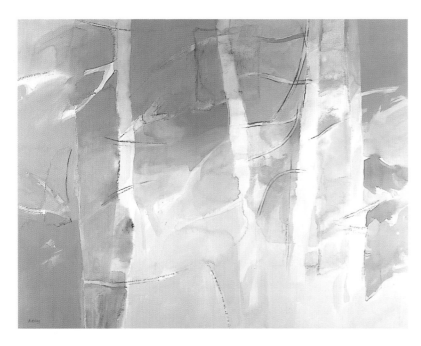

BARBARA KELLOGG
Whispers
Acrylic, gouache and
collage on paper
22" × 30" (56cm × 76cm)

Harmony of Dominant Light

Kellogg's mysterious painting suggests a cool northern atmosphere. Neutral grays are tinged with violet and pierced by cool yellow light. Abstraction benefits from the harmony of dominant light by creating an ambience felt by the viewer, even when the subject is vague or the painting is nonobjective.

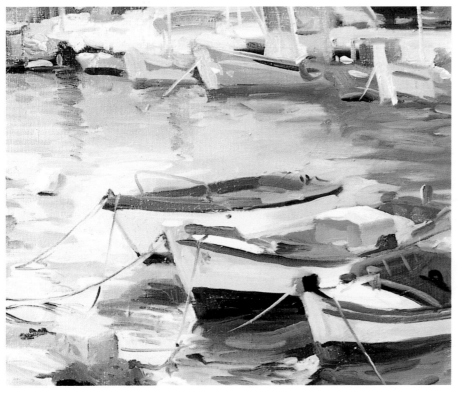

ELIN PENDLETON
Paros, Three Boats
Oil on canvas
18" × 24" (46cm × 61cm)
Collection of the artist

Sharp, Clear Light

Certain places come immediately to mind when you think of bright light creating dramatic contrasts, and the area around the Greek Islands is certainly one of them. Elin used Alizarin Crimson, Ultramarine Blue, Cadmium Yellow Pale, Thalo Green and Titanium White on gray-toned canvas to capture that sharp, clear light.

Weather

Changes in the weather also have strong effects on dominant light. Clear weather has sharp contrasts and strong colors; fog and mist have close values and limited colors. A rainy day may be all neutral, except for the heightened color of wet objects reflecting in the puddles. Sometimes you can get a dramatic sense of a sudden storm approaching with a sunlit area surrounded by a background of black storm clouds.

Exercise

DOING SOMETHING ABOUT THE WEATHER

List words that describe weather conditions, for example: sunny, partly cloudy, stormy, rainy. Look them up in a thesaurus or dictionary. What colors would you use to paint these different situations? Write ideas in your journal. Sketch a variety of weather conditions, using color to create the dominant light.

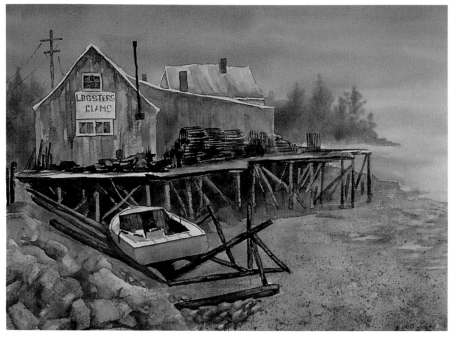

NITA LELAND
South Bristol Fog
Watercolor on paper
15" × 22"
(38cm × 56cm)
Private collection.

Warm Maine Fog

I used Cobalt Blue, Aureolin and Cadmium Scarlet to create the warm Maine fog in this watercolor. Cadmium Scarlet and Cobalt Blue make a dense granulating wash that beautifully represents fog: the only chromatic hues in the picture are in the foreground areas.

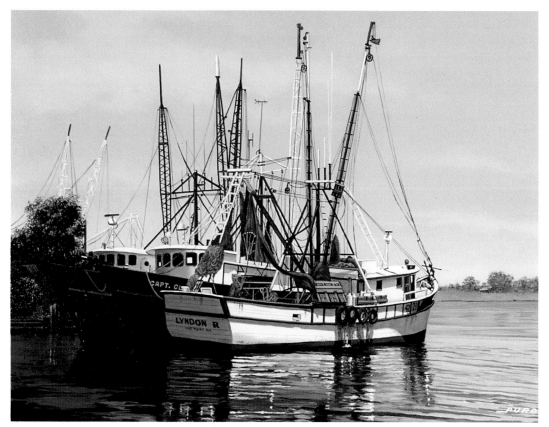

DOUGLAS PURDON
Quiet Harbour
Oil and alkyd on canvas
16" × 20" (41cm × 51cm)

Clear, Sunny Day

Purdon has captured a clear, sunny day to perfection with strong value contrast and clean color. The brilliant white of the boat flashes in the sun so you can almost feel its warmth, even though the temperature dominance is relatively cool.

Seasons

Many artists see winter light as cold and use cool Phthalo Blue and Violet with strong contrasts. Typical spring light is bright and tender, with gentler contrasts and clean, pure color: greens mixed with Cobalt Blue and Aureolin, and budding trees tipped with Rose Madder Genuine. The light of summer is more robust, with the rich color and contrast of a standard palette. When you think of autumn light, you might picture siennas and oxides against cool blue skies or brooding chromatic gray skies that imply the onset of winter.

Exercise

CAPTURING THE FOUR SEASONS

Let me persuade you to paint the four seasons one more time. It's a great way to work with light. This time, show the harmony of light in every season. Use some of the colors described here as your starting point, keying your color to characteristics of the seasons with compatible colors or color schemes.

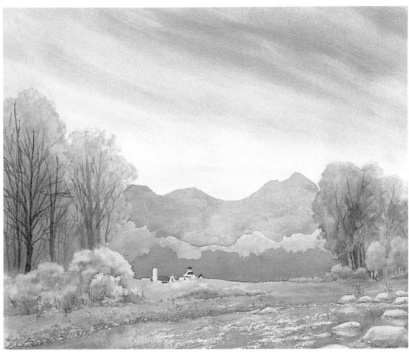

NITA LELAND
Colorado Rest Stop
Watercolor on paper,
18" × 24"
(46cm × 61cm)

Choose Colors Carefully

Blue skies and yellow cottonwoods are a dead giveaway for autumn in the West. But it makes a difference which blues you use to capture the season, as well as the place. I like Cerulean Blue here for the sky and water. It's neither too warm nor too cool and granulates beautifully in the background mountains.

ROBERT FRANK
Malbis Lane
Pastel on paper
12" × 17"
(30cm × 43cm)
Collection of the artist

Summer Light

Here the yellow is yellow-orange; the greens are deep and dark, with traces of olive. We're into summer now. Trees are weighted with thick, dark green foliage. Shadows are deeper as well, with just a trace of hazy summer sky. What other kinds of summer light can you envision? Sunlight on the beach? A flower garden in full bloom?

Color for the Seasons

Each season can be seen as possessing a unique natural harmony of color that is influenced by the special light and atmosphere of the time of year. Sometimes a painter will not see this and will paint just what he thinks they sees: The sky is "blue," therefore they paints it blue, right from the tube; the grass is "green," so artist paints it green, from the tube; the tree is "brown," so he uses brown paint from the tube. We become trapped in these preconceived images, forgetting to look at what light and atmosphere do to a scene or object. Any scene will be strongly affected by both time of year and time of day.

On the following pages, I've suggested a simple color palette for each season. These are meant as a departure point—not as a strict rule. It's true; you might use more blues in a winter scene and more greens in a spring scene. But don't use plain blue and green. Use the paints in values and gradations to show what you want us to feel about the season of that scene or object.

The artwork on pages 100-105 was created by Richard K Kaiser.

RICHARD K. KAISER
Farm on the Mountain
Pisgah, North Carolina
Watercolor
22" × 30" (56cm × 76cm)

There is nothing as satisfying as capturing a clean, crisp winter snow scene in watercolor.

Winter

Ultramarine Blue

Burnt Sienna

Alizarin Crimson

Burnt Umber

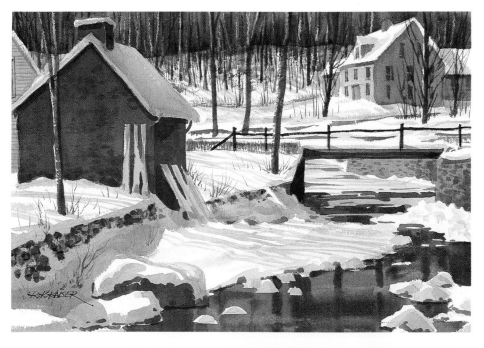

RICHARD K. KAISER
Winter in New Hampshire
Watercolor
10" × 14" (25cm × 36cm)

In winter, cool colors will be dominant. This was a crisp, snappy, cold morning and you can almost feel it. That sunlit snow with all the cast shadows really makes the scene come alive. I've added some cool blues and violets to the shadows because shadow colors are not just dark, dull gray. The warm neutral tones of the background house and trees also suggest a sunlit day.

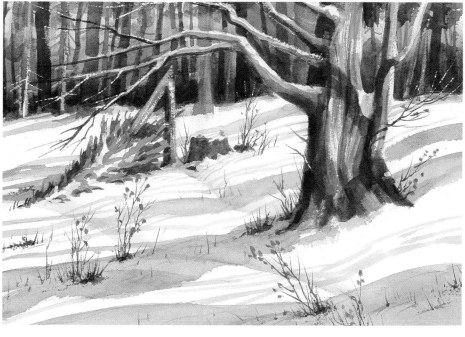

RICHARD K. KAISER
The Old One
Watercolor
10" × 14" (25cm × 36cm)

Snow, trees and shadows are such fun to paint. Notice how the blue-gray faraway trees seem to recede into the distance, and how the green fir and brown of the old tree come forward. The cool cast shadows create the form of the snowdrifts. The little touch of red on the twigs in the foreground adds a warm sparkle to an otherwise cool painting. Warm accents like these help relieve the almost monotone palette of a winter painting. You can also find color in the few leaves left on some of the trees.

Spring

Ultramarine Blue

Cerulean Blue

Burnt Sienna

Hooker's Green Dark

Raw Sienna

Cadmium Red Light

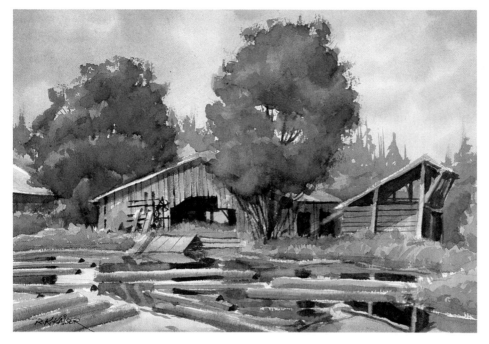

RICHARD K. KAISER
Lumber Mill
Jefferson, New Hampshire
Watercolor
10" × 14" (25cm × 36cm)

Spring has sprung in Jefferson, New Hampshire. Everything just "blossomed up," and you can almost smell the grass and trees. There are lots of greens, but spring greens are often purer and richer than summer greens. Yellow-greens often prevail in early spring. Next time you are outside, look at all the trees and bushes and observe all the different shades of green in front of you. The bright, clear sky also helps this painting show a "spring day."

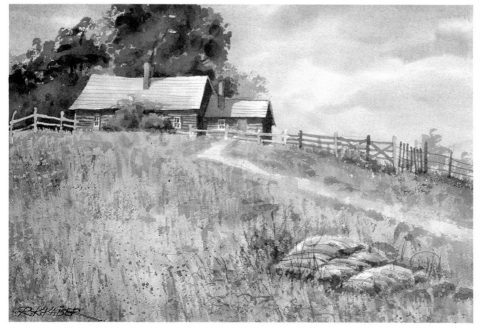

RICHARD K. KAISER
Cottage on the Hill
Watercolor
10" × 14" (25cm × 36cm)

Notice all the different colors of green, brown and red in the meadow leading up to the cottage. The suggestion of lots of wildflowers in the meadow clearly says "spring." By mottling the grass, I suggested a lot of detail where there really isn't any.

Summer

Ultramarine
Blue

Burnt
Sienna

Hooker's Green
Dark

Raw
Sienna

Burnt
Umber

Permanent
Rose

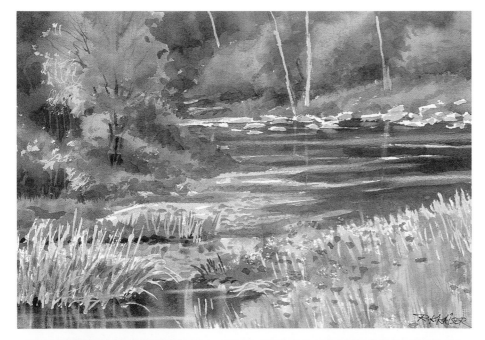

RICHARD K. KAISER
By the Stream
Watercolor
10" × 14" (25cm × 36cm)

It's a warm summer day by a trout stream. The greens in the painting are still on the bright side, but a few greens tend to be yellow-brown. As summer goes on, most greens go toward brown. Control your greens. Don't make a summer painting just a "big green monster."

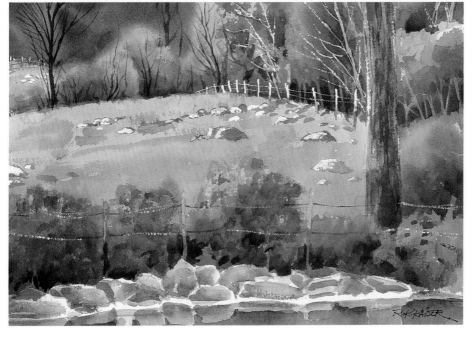

RICHARD K. KAISER
The Pasture
Hamilton, New York
Watercolor
10" × 14" (25cm × 36cm)

Just suggest those faraway trees—don't paint a portrait of each one. Again, watch that your greens aren't all the same. Here I've alternated values of green from light to dark and dark to light to give the feeling of depth (the hill) and form (the trees). The pervasiveness of green—almost an overgrown look—will give your paintings a summery look.

Fall

| Ultramarine Blue | Cerulean Blue | Burnt Sienna | Cadmium Orange | Gamboge Hue | Winsor Yellow | Alizarin Crimson |

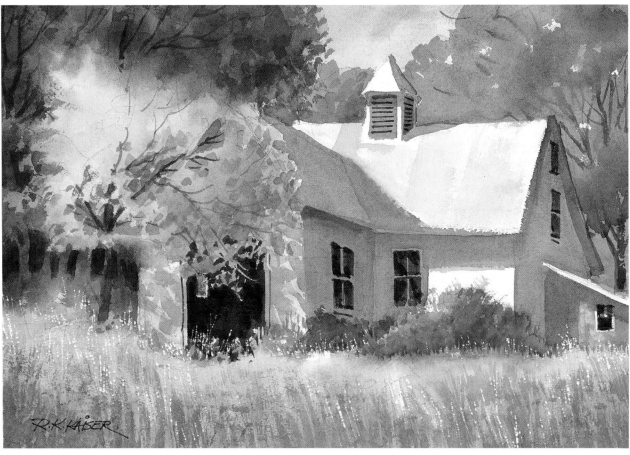

RICHARD K. KAISER
Fall and Barn
Watercolor
10" × 14" (25cm × 36cm)

It's just a white barn and a few fall-colored trees, but look what you can do with color. The white barn has a lot of shadow areas into which I've flowered various colors reflected from the surrounding grass and trees. The coolness of these shadows brings out the brilliant warmth of the trees. But be careful not to get too garish with your warm autumn colors. Nature's colors, though marvelously bright, are seldom pure hues. Use your brightest colors sparingly.

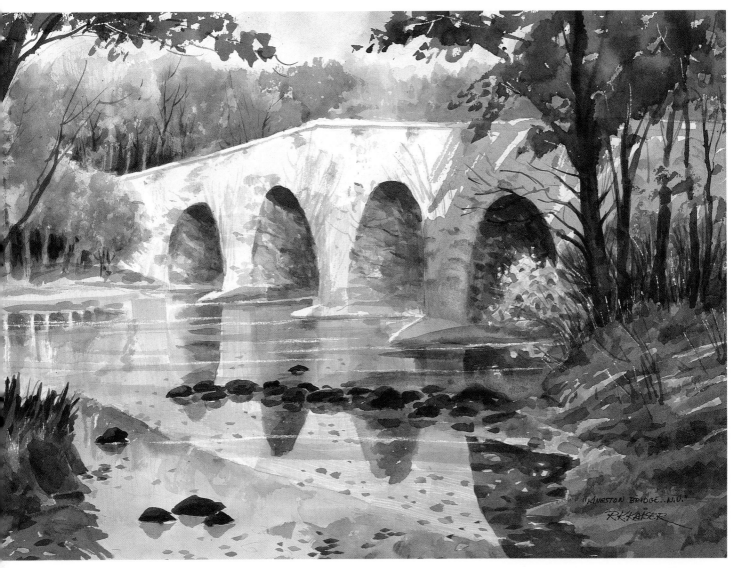

RICHARD K. KAISER
Kingston Bridge, New Jersey
Watercolor
15" × 22" (38cm × 56cm)

The early fall, when only some of the trees have turned, is a beautiful time to paint. The complementary contrasts of the remaining green leaves with the newly turned leaves of red, orange and yellow make an exciting color scheme. Here all these contrasts are kept from being overwhelming by the large neutral areas of the bridge and water. It's important to remember how helpful neutral colors can be—especially during the brightly colored autumn season.

Wispy Clouds

For the graceful softness of these clouds, you need a dark background so the light shapes will show up. Your wash must be rich in consistency but not drippy. Timing is essential; measure it in seconds, not minutes.

The artwork on pages 106-117 was created by Zoltan Szabo.

The 2-inch (51mm) wide, soft flat brush is vertical, and the paper is just damp. Drag the brush through the moist color with a back-and-forth twisting motion while gradually and simultaneously releasing the pressure. Repeat this technique several times, wiping the brush clean after each application.

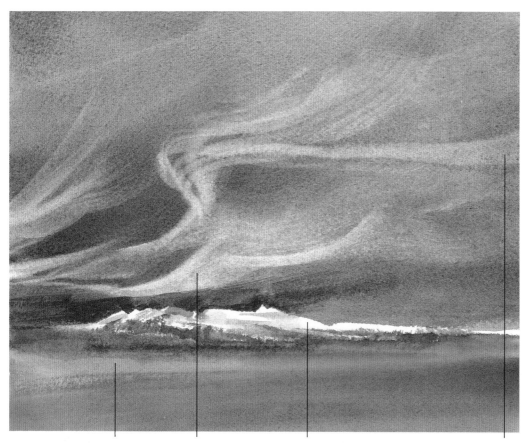

Wet-into-wet warm color complement.

Brushed several times with a thirsty, damp brush.

Negative shape left white.

Brushed only once with a thirsty, damp brush.

The sky is a loosely mixed wash of Magenta, Gold Ochre, Burnt Sienna Light, Ultramarine Blue Deep and Cyanine Blue. I squeezed all the water I could out of a soft 2-inch (51mm) flat brush and rolled the edge of this thirsty brush with gentle pressure into the damp color to lift out the wispy cloud shapes. After each contact I wiped the brush clean with a tissue, then repeated the action until I was satisfied. I did not touch the shape of the white mountains. I added the hint of the grassy foreground with fast, decisive brush-strokes using Gold Ochre and Cyanine Blue.

The big difference between the sketch below and the sketch on the facing page is that the sky in this one is dominated by Phthalo Blue. The color of the lifted clouds ended up blue because the Phthalo Blue is staining. On the first sketch, the sky is a neutral color and therefore lifted white. In both cases, it is essential to wipe off the lifted color and squeeze the brush thirsty-dry after each contact with the damp paint. This way you won't dirty up the clean wiped clouds.

The paper is just moist, the shine just about to go dull, when you move the 2-inch (51mm) wide soft flat brush through the damp color with a back-and-forth twisting motion lifting off the light clouds. Press the damp and thirsty brush a little harder at first, then release the pressure gradually until the brush is completely off the surface. Repeat this several times, wiping the brush clean each time.

Thirsty, damp brush marks rolled into damp color.

Simultaneously applied dark cool and light warm colors.

Overlapping thirsty damp brush marks.

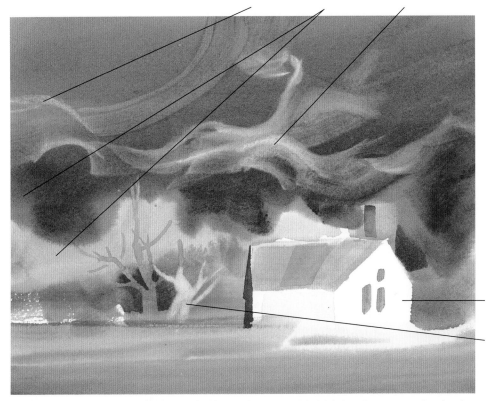

Negative shape left paper-white.

Light shape lifted out after drying. Phthalo Blue staining dominance.

The dark sky is a combination of Phthalo Blue and a touch of Gold Ochre. I swept out the clouds the same way as in the first picture. The very dark sky creates strong contrast and intense drama. The shape of the house was left white and the trees behind it, as well as the foreground, were washed with Gold Ochre, Rose Madder and Phthalo Blue in varied combinations.

Cumulus Clouds

Because the soft edges of the white clouds are painted with a strong staining color, the edges must be achieved with dark colors and decisive motion. Don't expect to go back and fix them; you won't get away with it because of the staining nature of the pigment. If you lift the color later you'll get a blue tint.

Area left pure white.

Simultaneously painted warm colors.

Phthalo Blue-dominated dark wash on wet paper.

Burnt Sienna and Ultramarine Blue combination.

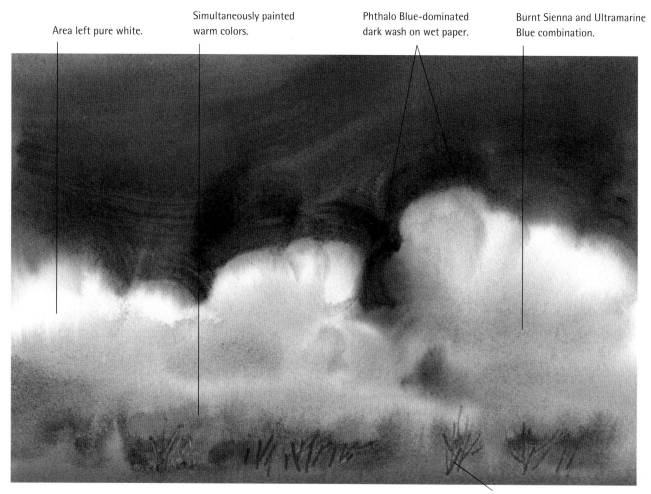

Lines scraped into wet paint with the point of a round brush handle.

On a wet paper using a 1-inch (25mm) slant bristle brush loaded with a very rich mix of Phthalo Blue and Winsor & Newton Sepia, I painted around the top edges of the white clouds. Because my paint was very thick, the edges simply softened but stayed readable on the damp paper. For the bottom section of the clouds, I painted the gray with a mixture of Burnt Sienna and Ultramarine Blue. I dropped in a bit of green grassy area (Phthalo Blue and Gamboge Yellow) and hinted at a few autumn trees (Gamboge Yellow and Burnt Sienna). The darker lines indicating tree trunks at the bottom were scraped into the still-wet paint with the round point of a small brush handle.

Stratus Clouds

The light colors must be built up by going from the white paper to light colors and to darker colors last. Each time you add value to your brush, think of the light shape next to the brushstroke. Think of the negative shapes while you paint the positive strokes.

Several medium-dark glazes.

Light-glazed repetitive shapes.

Dark colors applied last.

White paper left untouched.

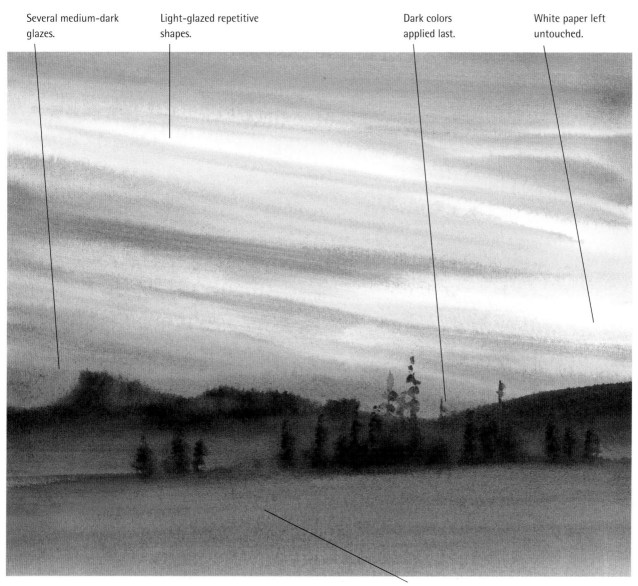

Warmer ground color.

On a wet surface, I treated the windswept clouds as negative shapes. Negative shapes are "left out." They are defined by painting darker colors next to or around them. I brushed in a combination of three analogous colors: Ultramarine and Cyanine Blues and Phthalo Green in varied dominance. For the dark edge of the middle ground, I applied Phthalo Green, Ultramarine Blue and Rose Madder, plus a little Gamboge Yellow for the grassy foreground.

Dramatic Clouds

This effect requires a color removal technique. Don't leave your wet colors on the paper too long before you use the tissue to lift them off. The more quickly you act, the whiter the clouds will look. It is important to change the tissue after each contact to prevent reprinting the color you have just lifted off.

The wash is shiny wet, but not dripping. Repeatedly press the bunched-up paper tissue into the wet paint, lifting off the cloud shapes. Repeat the contact, but turn the tissue each time to make sure that only its clean area touches the paint.

Tissue-blotted clouds.

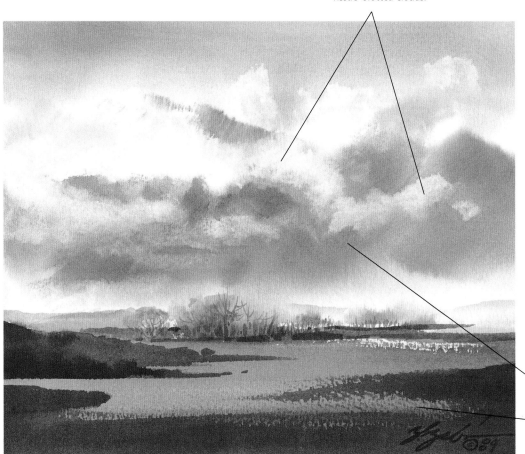

Original dark blue wash on wet paper.

Drybrush stroke.

My colors were Cyanine Blue, Rose Madder, Burnt Sienna and Gamboge Yellow. I painted the sky and the high mountains on a wet surface simultaneously. Cyanine Blue, Rose Madder and a touch of Burnt Sienna supplied the right combination for the background. I lifted out the white clouds by pressing a bunched-up paper tissue into the wet paint. The tissue absorbs the water and paint immediately and surface-dries the paper wherever it touches. I also dropped in the warm-colored autumn trees and several glazes of dark warm washes in the foreground to show color perspective.

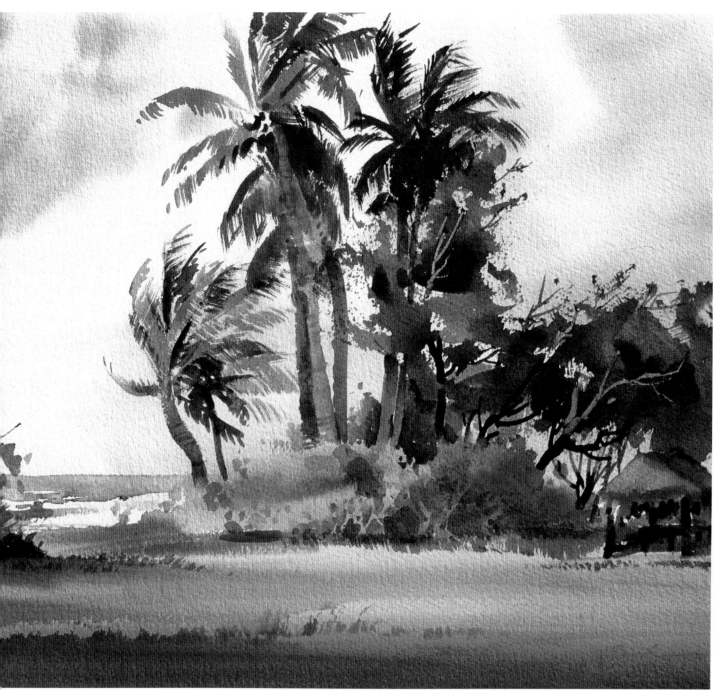

ZOLTAN SZABO
Trade Wind
Watercolor
15" × 22"
(38cm × 56cm)

One of the most important sections of this Hawaiian painting is the sky. To indicate breezes, I established the wind-blown clouds by not painting them. I painted the blue sky around them on wet paper, leaving the clouds' edges soft. Against this light background, I painted the contrasting palm trees, their branches bending with the wind. These branches were painted with a slant bristle brush loaded with rich pigment and a little water. I drybrushed most of the dark vegetation in cool shadow colors. At last I painted the sunny foreground with warm dominance on the grass. The exciting pattern of the tropical trees shows very well against the simple but fresh background.

Heavy Fog

Fog can create moody and mysterious visual conditions. While very close objects can be colorful and clear, other objects quickly seem to melt into the atmosphere as they move toward the distance. The shapes behind the fog must be painted first with dominating staining colors like Payne's Gray or Sepia. If your first wash doesn't stain, it will come off when you glaze the fog on top of it no matter how gentle you are. For the fog, don't be stingy with the color. It should be about as thick as table cream but still definitely liquid.

Heavy fog is painted with a thicker consistency paint. Mist is painted with thinner paint, but is painted in the same manner (see pages 114-117). When the color dries, it will regain its luminosity.

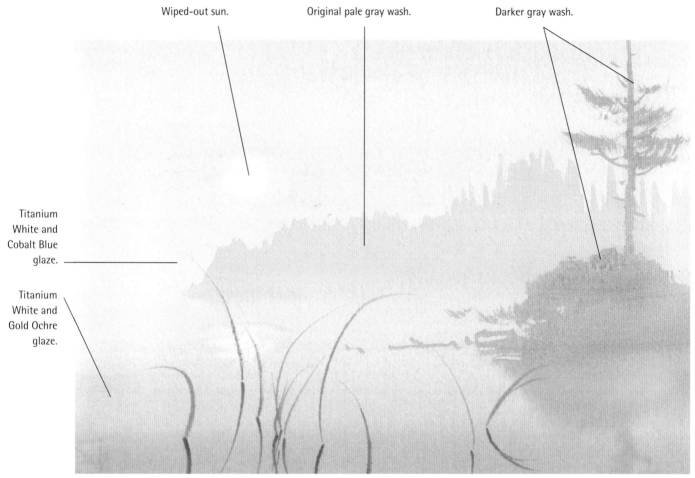

Wiped-out sun.

Original pale gray wash.

Darker gray wash.

Titanium White and Cobalt Blue glaze.

Titanium White and Gold Ochre glaze.

For this moody fog study, I painted the background trees and the dark tree silhouette with Van Dyke Brown and Payne's Gray onto my dry paper. When these were dry, I painted a rich reflective wash of Cobalt Blue, Titanium White and Gold Ochre over the original design using a 2½-inch (63mm) soft slant brush. Last, for the dark foreground weeds, I used Gold Ochre and Cyanine Blue.

Whenever you paint dark colors on top of a dry but opaque wash (as I did in the foreground below), apply the color quickly to avoid digging up the light color. With repeated wet brushstrokes, the color will actually get lighter. If you need to go back because you didn't go dark enough, wait until it dries again and repeat your dark color on a dry surface.

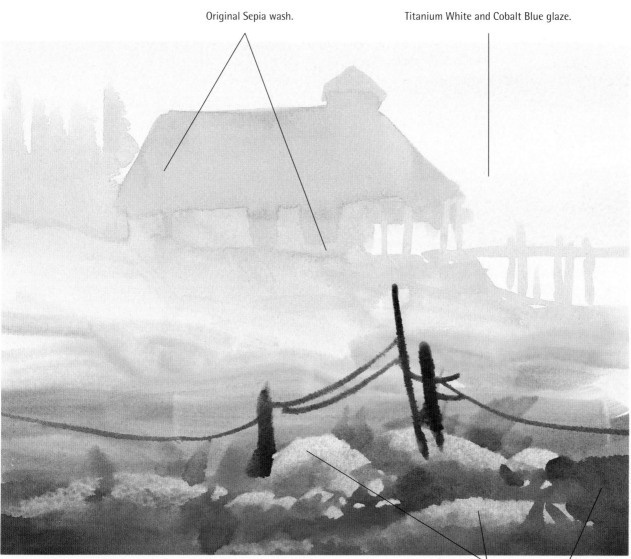

Original Sepia wash.

Titanium White and Cobalt Blue glaze.

Palette-knife-scraped light area.

Rocks painted with warm foreground colors.

For the background building and dock, I used a thin wash of Winsor & Newton Staining Sepia. After it dried, I glazed the fog on top with a mix of Titanium White and Cobalt Blue. My foreground colors, painted last, were Venetian Red, Winsor & Newton Sepia, Cobalt Blue and a touch of Aureolin Yellow for the weeds.

Distant Mist

ZOLTAN SZABO

The subject of this painting is a subtle one. I painted it from a photograph of an island engulfed in fog. The fog was so thick that the photographs showed only the dark mass of the house on the island.

These are the colors you will use:

Sepia. A neutral, staining color that will get weaker when diluted but will not move or come off when dry. Be gentle with it.

Cerulean Blue. A naturally soft, pastel color. It is opaque and will be used to cover some of the Sepia in the background.

French Ultramarine Blue. A warm, somewhat violet color that will be used to make the Sepia less harsh.

Raw Sienna. A mellow, neutralized yellow that makes a good green when mixed with Antwerp Blue.

Antwerp Blue. A blue with a little green in it.

Burnt Sienna. A real work horse; a dull but pure orange. It is neutral and transparent.

| Sepia | Cerulean Blue | French Ultramarine Blue | Raw Sienna | Antwerp Blue | Burnt Sienna |

1 PAINT THE SILHOUETTE

On a dry paper, paint the silhouette shape of the cabin using a large, wide, soft brush and a light wash of Sepia and French Ultramarine Blue. The color should be rather light; I suggest you test it on scrap before painting. Work fast so it is a unified whole. Lose the bottom edge of the shape so it is soft. While the shape is still damp, paint the dark shadow side of the building. Let the paper dry.

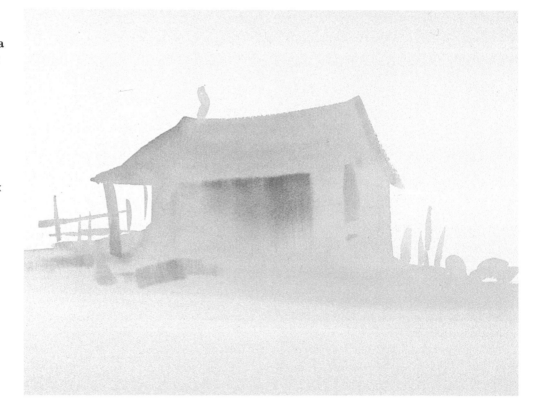

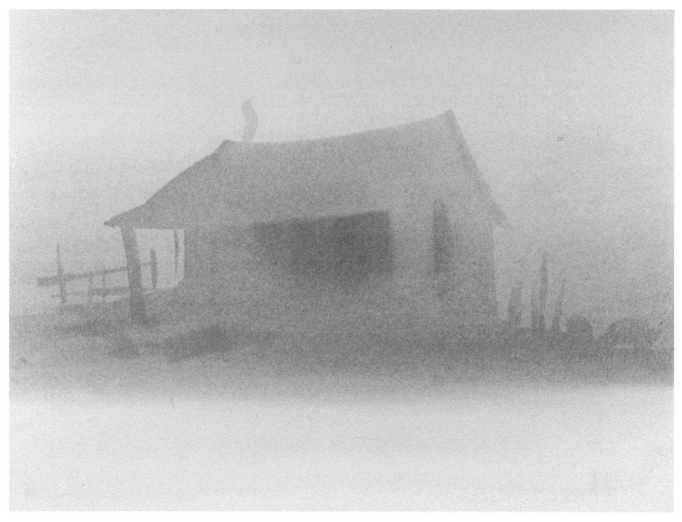

2 CREATE A MIST

Wet the whole paper with the wide, soft brush. Use clean water and back-and-forth horizontal strokes. Go right over the house. Since you used staining colors and are not scrubbing the color with the brush, the color should not move. Now wash over the entire image with Cerulean Blue and Raw Sienna.

Add a wash of Raw Sienna and Burnt Sienna, and use the same stroking motion on top of the previous wash to warm it up a little. Add more Cerulean Blue to the mixture and continue applying the color. It may take two or three continuous applications until there is enough color to make the image misty.

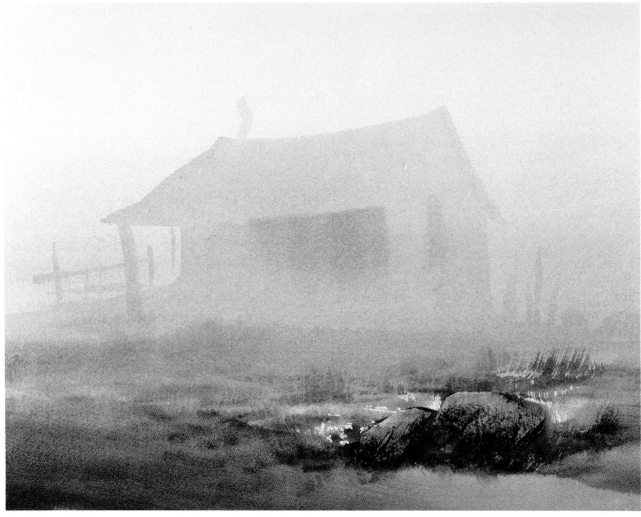

3 GRASS TEXTURES

Add some Raw Sienna to the mixture to make it more yellow. Use the 2-inch (51mm) slant brush and blend the mixture into the existing colors on the bottom to make a warmer foreground. Make a grayish green, then touch the paper with the bristle tips and flick the brush upward to create the texture of grass. Add Antwerp Blue to make a darker green. Neutralize this with Burnt Sienna and Antwerp Blue to make a dark, warm foreground.

Use a dark, rich tone of Burnt Sienna, Raw Sienna and French Ultramarine Blue to make a foreground rock. Add Antwerp Blue and French Ultramarine Blue for the shadow at the bottom of the rock. While it is still damp, texture the rock with the heel of the palette knife. Make the top surfaces lighter, tapering to a dark toward the bottom.

Mix Cerulean Blue and Raw Sienna to make a grass-green, and add a little Antwerp Blue and Raw Sienna for foreground grass. Detail and texture the foreground with a 2-inch (51mm) slant brush to make clusters of grass.

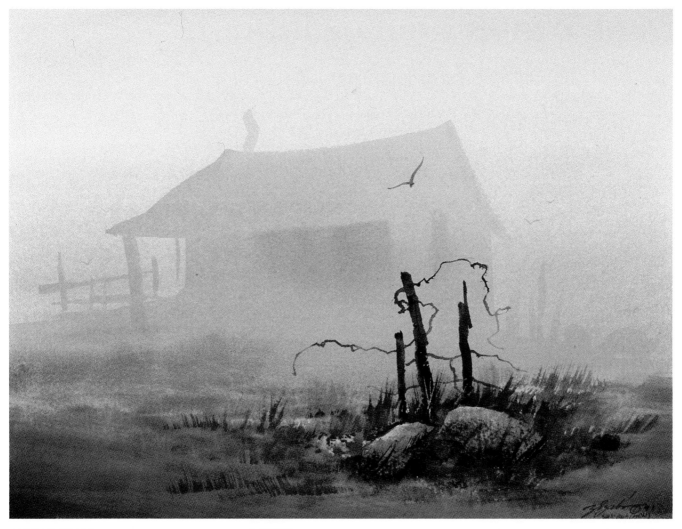

ZOLTAN SZABO
Peaceful Corner
Watercolor
15" × 20"
(38cm × 51cm)

4 **FINISH**
When the previous step is dry, lay down a pale coat of Cerulean Blue in the foreground to color any white speckles. With a mixture of Cerulean Blue and Antwerp Blue, flick your soft 1-inch (25mm) flat brush with your fingers to make splatter on this foreground area. This will add some nice touches of blue sparkle.

Mix Antwerp Blue and Burnt Sienna to make a dark for the dark, weed-like clusters behind the rock. For the extensions beyond, use French Ultramarine Blue and Raw Sienna.

Now add Sepia and Antwerp Blue to the basecolor to make a fence post. Add colors to enrich it. Paint behind the grass at the base, then use the tip of the brush handle to scrape out light weeds in front of the post. Stay playful; don't try to predetermine exact results.

Use the point of the palette knife to make wires on the posts. Don't force things, just let them happen. Add a few more sharp accents to contrast with the softness of the rest of the painting and to make this place the center of interest.

Texture the foreground with Dark Green. Add the bird if you like, but be sure to keep it lighter than the fence.

Paint Winter Scenes Indoors

Snow and watercolor go quite well together—the sparkle of one very much in tune with the brilliance of the other. Without a doubt, painting on location is the best way to learn. Even the finest camera and film can't capture the colors that glow in every shadow, nor the subtle light that bounces from every surface. Yet, I'm the first to admit that it's not much fun standing ankle-deep in snow trying to complete a painting before my water (and my toes) freeze! These days, winter is a pleasure I enjoy best from a distance. While I still do an occasional winter painting on location (see *Lake Mary*, below), the majority of my snow paintings are based on photos from my files, backed by years of observation and experience.

The artwork on pages 118-125 was created by Marilyn Simandle.

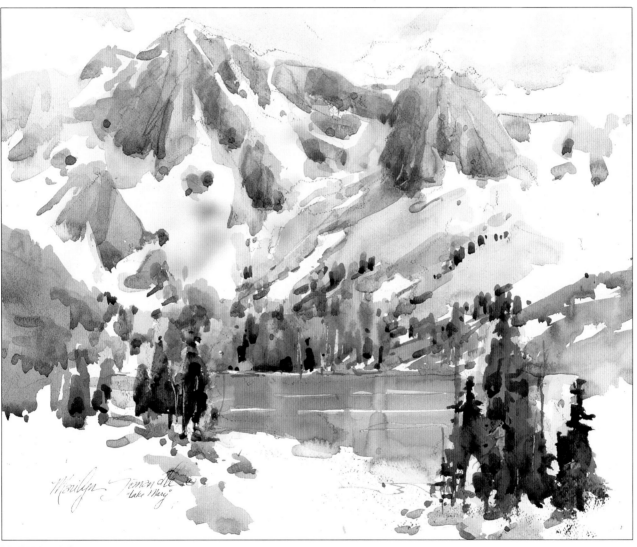

MARILYN SIMANDLE
Lake Mary
Watercolor
12" × 16" (30cm × 41cm)

Quick Winter Piece
I offer this little painting as proof that I still paint on location, even in winter. I did it with palette and paints spread out on the tailgate of our truck in a wind-blown, finger-freezing, foot-stomping half hour. My Cadmium Orange actually froze while I was working! On the plus side, though, I find that I often do my best work when I push myself to finish quickly.

A Sparkling Winter Scene

MARILYN SIMANDLE

I love the tree shapes against the snowy hill . . .

. . . and the reflections in the stream.

The old house, with its wonderful shadows, will make a nice point of interest.

Great trees and shadows!

Let's use this brook flowing through the snow.

Assemble the Ingredients

Using several scenes from my files, I've decided that the point of interest for my next painting will be that solid old house which, you'll notice, was photographed in summer. The winter photos will be invaluable for shadows, form, value and inspiration. This is the way I work in my studio, often with ten or more photos for reference. Rarely is a single snapshot exactly what I want. Your painting should be as you want it to look.

KNOWING AND INERPRETING WINTER

It's still a great help to have experienced and painted winter from direct observation. I've been there—I have come to know winter and its subtleties—and over the years I've interpreted it in countless paintings.

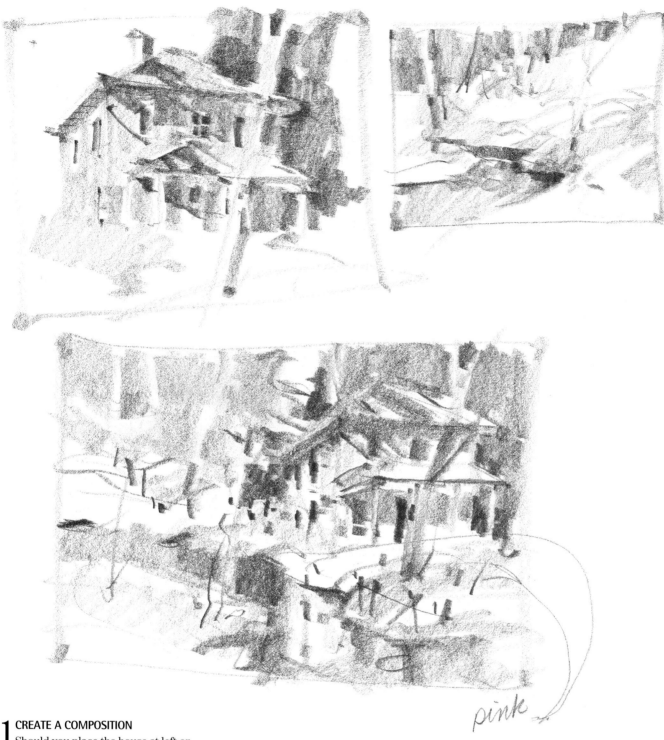

pink

1 CREATE A COMPOSITION

Should you place the house at left or right? Where to place the stream? Shadows are very important. Where should they fall and what kind of connected shadow pattern will work best? Begin by blocking out big shapes and bold values. A value sketch will help define composition and establish the value pattern.

2 PUT IT ON WATERCOLOR PAPER

Though I'm known as an artist who paints loosely, I like to work from a precise, accurate drawing. That's not a contradiction. A careful drawing establishes the composition, frees you from thinking about objects and allows you to concentrate on shapes.

Sketch standing up if you can, your 6B pencil held flat against the paper to get your whole body (not just fingers and wrist) into the motion of sketching. Draw the house first because it is the major shape and point of interest. Next comes the stream.

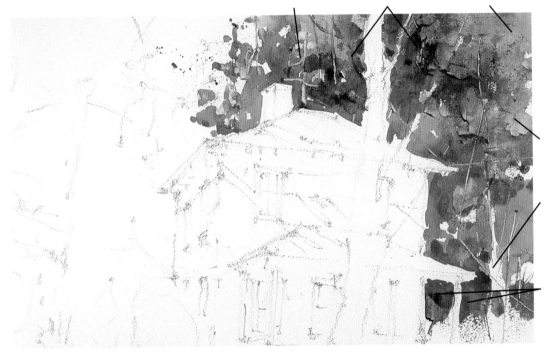

Scratch and smear moist washes with your palette knife.

Raw Sienna and Manganese Blue.

Begin here: Manganese Blue with Permanent Rose and a touch of Raw Sienna.

Blend warm and cool, dark and light, to keep each wash colorful.

Leave more whites for sparkle and light than you think you'll need!

When painting "behind" something, be sure to carry colors from one side to the other.

3 CREATE THE BIGGEST VALUE SHAPES FIRST

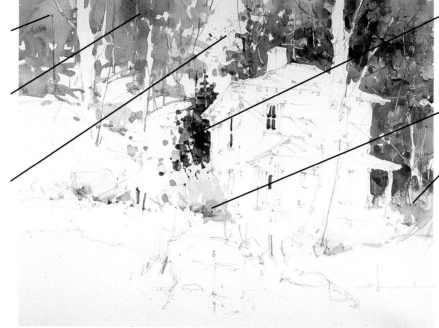

Cooler, grayer, lighter values (a mixture of Cobalt Violet and Permanent Rose) recede.

A mixture of Cobalt Blue and Raw Sienna makes a soft green.

This area offers a visual escape from the point of interest.

Establish darkest value with a mixture of Antwerp Blue and Burnt Sienna. Use Sap Green for lighter greens.

Drop in a touch of Cadmium Red Medium while wet.

Wintry shrubs are a mixture of Permanent Rose and Cadmium Orange.

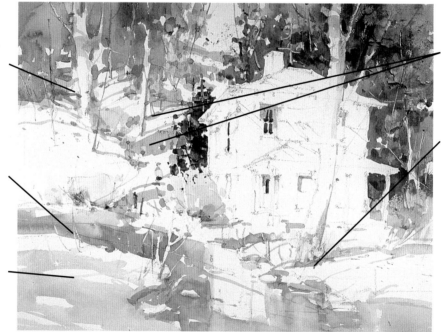

Background shadows and trees are close in value range.

Begin the stream with a mixture of Antwerp Blue, Raw Sienna and Permanent Rose. Scratch lines as you go.

Foreground snow shadows are warmer than the stream: Manganese Blue, Permanent Rose and Cadmium Orange over a very light glaze of Cadmium Orange.

Know your light source: Be sure to keep shadows going in the same direction.

Darker snow shadows are lit by the sky: Cobalt Blue and Permanent Rose.

4 DEFINE FOREGROUND COLORS

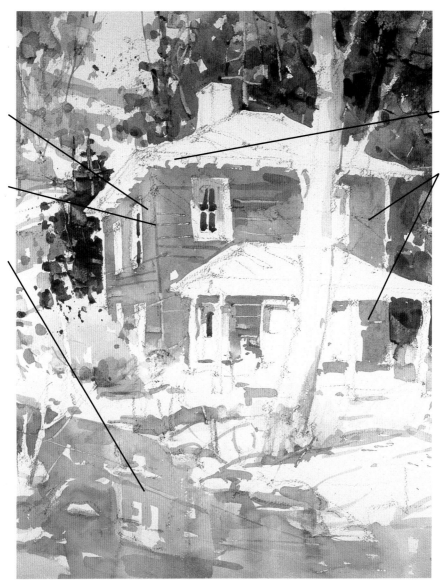

Begin with the local color: Cadmium Scarlet and Cadmium Orange.

Scratch lines for siding.

Don't forget reflections and how moving water breaks them up.

Make edges interesting.

Keep varying colors in your washes as you go.

5 DEVELOP THE POINT OF INTEREST
Remember that the brightest colors, strongest contrasts and the most detail should all be in the point of interest.

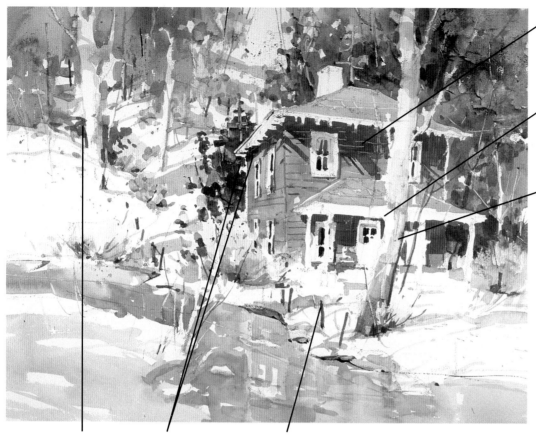

Glaze shadows with a mixture of Burnt Sienna, Alizarin Crimson and a touch of Antwerp Blue.

Make good use of lost and found edges wthat blend into other shapes and then reappear.

The tree trunk is dark against light background, light against dark.

Dark elements here help balance the point of interest.

Connecting these darks helps the eye move from tree to house.

Snow shadow colors (Cobalt Blue and Permanent Rose) also move around the painting.

6 FINISH BLOCKING IN FORMS

LESS IS MORE

One of the hardest things to know is at what point a painting is finished. The impulse is to keep adding detail long after we should have stopped. More paintings are lost at this finishing stage than at any other. My husband, Ted, often says that every artist should be two people: one who paints and another who hits the painter over the head and tells him to stop.

Watercolor works best when it implies rather than describes. Look at that tree in front in *The House by the Stream,* and notice how little it takes to make it work. Like the poet who uses very few words to say volumes, the painterly painter uses very few brushstrokes, regarding each painting as a conversation in which the viewer will actively participate to fill in the details.

Adding too much detail, the artist ends up (boringly) dominating that conversation. That's why it's important not to fuss with small areas in your painting. The noted English painter, Sir Joshua Reynolds (1723-1792) once pointed out that "painting blades of grass is a sign of idleness, not industry." Amen to that! Get in there, get it down and leave it alone!

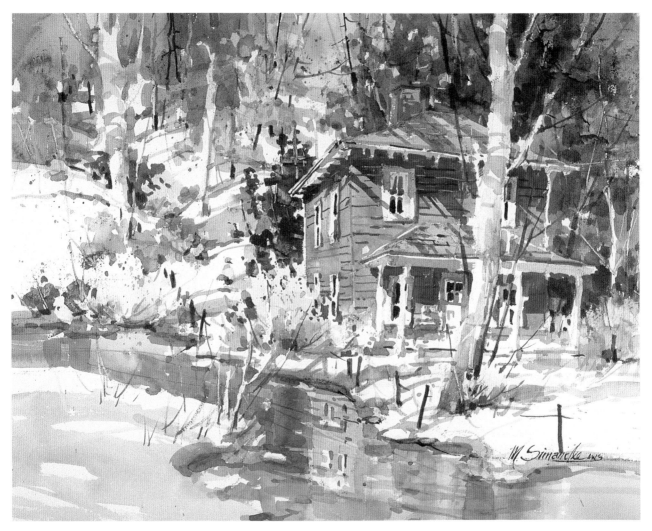

7 ADD FINISHING TOUCHES

Now it's time to adjust values. Lay some accents of pure Permanent Rose and Cadmium Orange into the point of interest, and add just a few calligraphic lines to describe siding, roof, tree branches and grasses. Decisions are based on what's to be brought forward or moved back, what should draw the eye and what should not.

Finally, stand back and evaluate your painting. Have you achieved harmony and variety in large and small shapes? In light and dark values? Are the brightest colors, strongest value contrasts and finest detail concentrated in the point of interest? If you're not quite sure, turn your painting upside down and look at it. You'll see it as an unfamiliar abstract, and the patterns of shapes and values will be more visible.

MARILYN SIMANDLE
The House by the Stream
Watercolor
16" × 20" (41cm × 51cm)

INDEX

Unlock the Secrets of Great Painting!

Keys to Painting Faces & Figures

Top artists share proven techniques for painting portraits, distant figures, bustling crowds and more. It's some of the best step-by-step instruction ever published by North Light Books—from how to use light, composition and color effectively to full-length painting demonstrations. No matter what your medium or painting experience, these keys will help you unlock new levels of expression in your faces and figures.

0-89134-976-6, paperback, 128 pages

Keys to Painting Trees & Foliage

Capture the splendor of nature in your paintings with realistic trees and foliage. This compilation of classic North Light instruction features advice from a prestigious gathering of landscape artists—each a master of rendering realistic trees and foliage in watercolor, pencil, charcoal, pen and ink, oil, acrylic or pastel. You'll learn from such artistic luminaries as Stanley Maltzman, Claudia Nice, Zoltan Szabo and others!

1-58180-187-4, paperback, 128 pages

Keys to Painting Fur & Feathers

Nothing creates a stronger sense of "life" in your wildlife art than realistic textures. This collection of some of North Light Books finest art instruction will show you proven ways to paint fur, feathers and other realistic wildlife textures. You'll find easy-to-follow instruction and step-by-step demonstrations from top wildlife artists in a variety of mediums, including acrylic, oil, watercolor and pastel.

0-89134-914-6, paperback, 128 pages

Keys to Painting Light & Shadow

More than any other single element, light can bring drama, emotion and power to your paintings. Find out how with this invaluable guide, filled with proven techniques and easy-to-follow instruction from top artists. These pages hold some of the best step-by-step instruction ever published by North Light Books—from creating lively sunlit effects to designing strong compositions using light and shadow.

0-89134-931-6, paperback, 128 pages

Keys to Painting Textures & Surfaces

Discover the tricks to creating realistic textures from 12 expert artists! This book features beautiful art and clear, easy-to-follow demonstrations in a host of mediums. Step-by-step, you'll learn how to achieve the look of elegant lace, rusty metal, luscious fruit, sparkling crystal, jagged rocks, delicate porcelain and many other surfaces. No matter how long you've been painting, these textural secrets will help bring your paintings to life.

1-58180-004-5, paperback, 128 pages

Keys to Painting Buildings & Barns

Buildings are more than bricks and boards—they have stories to tell. Discover a range of techniques for painting expressive "portraits" of your favorite homes and buildings—from cottages and barns to mansions and cityscapes. This is some of the best instruction ever published by North Light Books, covering everything from perspective and composition to how to paint stone, brick, wood and other textures step-by-step.

0-89134-977-4, paperback, 128 pages